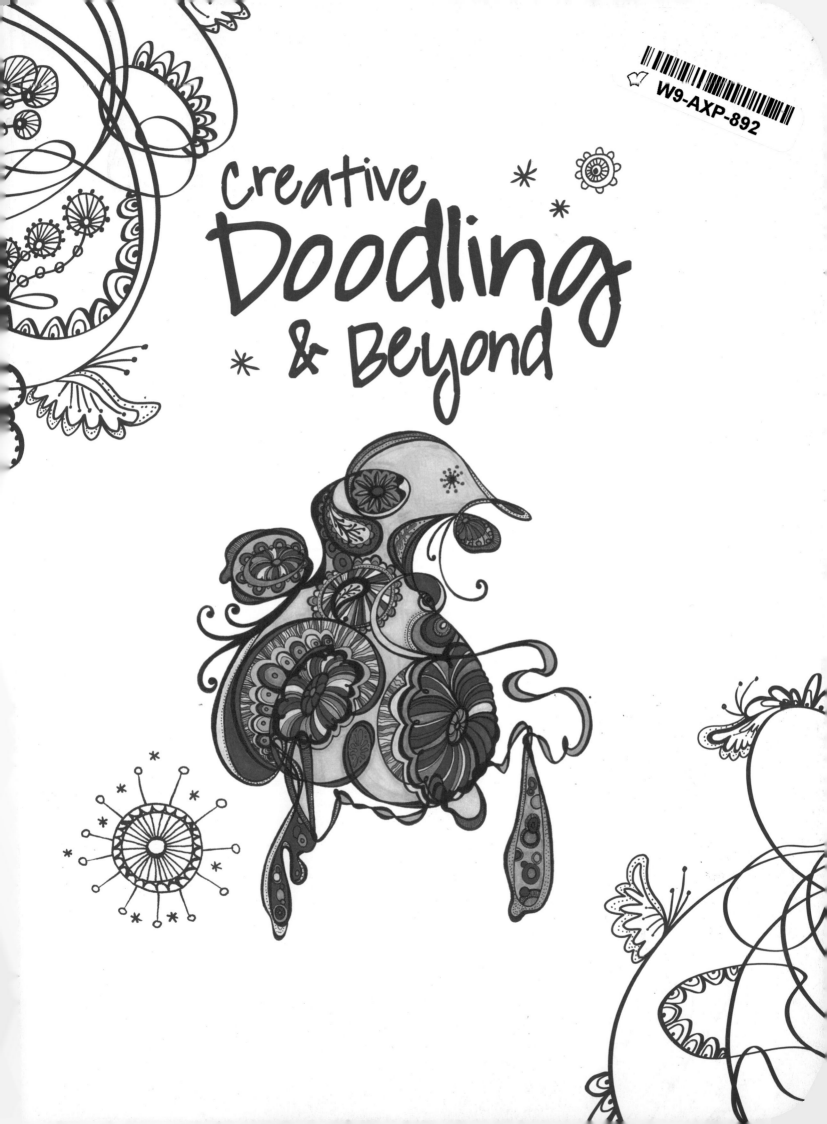

Creative Doodling & Beyond

www.walterfoster.com
Walter Foster Publishing, Inc.
3 Wrigley, Suite A
Irvine, CA 92618

© 2011 Walter Foster Publishing, Inc.
All rights reserved. Walter Foster is a registered trademark.
Artwork and photographs © 2011 Stephanie Corfee, except
photograph on page 60 © 2011 Bruce Sandstrom,
Sandstrom Land Management
Roseville, Minnesota

Associate Publisher: Elizabeth T. Gilbert
Art Director: Shelley Baugh
Project Editor: Rebecca J. Razo
Senior Editor: John Welches
Production Designers: Debbie Aiken, Amanda Tannen
Production Manager: Nicole Szawlowski
Production Coordinator: Lawrence Marquez
Administrative Assistant: Kate Davidson

5 7 9 10 8 6

Table of Contents

Introduction

"Doodle" is an informal term that describes a loose, whimsical art form characterized by scribbly lines, loops, curves, and quirky designs. It's fun, it's liberating, and anyone can do it. Best of all, there are no mistakes in doodling. In fact, what you might perceive as a mistake is more likely just a bit of added character! You can see the human touch in a doodle's imperfect, wobbly shapes. Mostly, though, doodles are a means of self-expression. And that's what art is all about.

As an artist, I am always drawn to work that allows me to "see" the maker's hand. I've never found straight edges and perfect geometric shapes appealing. So doodling was an obvious and natural fit for me. And over the years, I have filled my share of notebooks and scraps of paper with my drawings. Recently, I've started to hone my particular doodling style and have begun applying my designs to everything from clothing to home decor. I love art that is as functional as it is beautiful, and doodling suits my philosophy that one's most prized possessions are not items that are store-bought and pristine, but rather those that are personal and homemade. The purpose of this book is to...

* inspire you to abandon your preconceived ideas about what art is and isn't;
* show you how easy it is to doodle;
* teach you how to create beautiful art using doodles, as well as how to apply doodles to functional objects; and
* help you connect to your inner artist!

It is my hope that by the time you finish the exercises and projects in this book, you will not only find inspiration everywhere, but you will also habitually tote doodle notebooks with you wherever you go, filling them with happy little pen marks and drawings on every page!

Stephanie Corfee

How to Use this Book

The information contained in this book is designed to inspire you to see the world of art through a new set of eyes: a doodler's eyes! After learning about some of the basic tools and materials you'll want to have readily available, you'll learn some fun and easy ways to ignite your doodling spark. You'll then be invited to try your hand at replicating a variety of patterns, borders, and other elements directly in the pages of this colorful workbook. And from there, the real fun begins!

From doodling with your eyes closed and doodling with your non-dominant hand to creating your own keepsake family heirloom doodles, you'll be treated to a variety of engaging creativity prompts, exercises, and step-by-step projects designed to teach you the fine art of doodling, as well as encourage you to see doodling in a whole new light. Open practice pages throughout the book allow you to try out the techniques described and put your newfound doodle skills to work! The book culminates with an Idea Gallery that shows even more creative ways you can incorporate doodles into everyday art and decor.

Happy doodling!

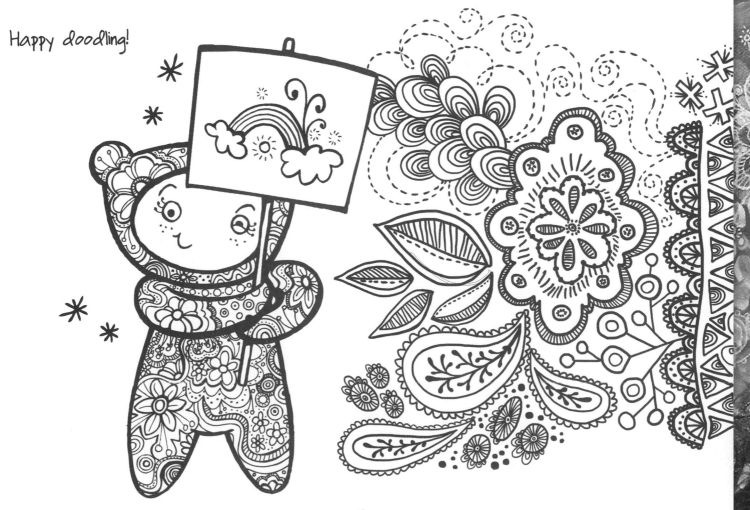

Basic Tools & Materials

Doodle supplies needn't be costly. Any old pen or pencil and scraps of paper will do in a pinch. I've scrawled some of my best doodles on the backs of receipts, cocktail napkins, and the like; however, if you'd like to build a more specific collection of supplies to feed your doodling habit, here are some of my absolute favorites.

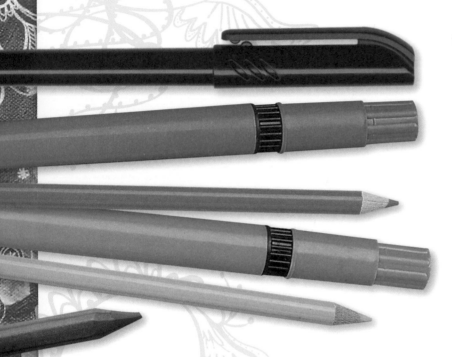

Writing Instruments

Archival Ink Pens Try to have a selection of pens in every tip size. Sizes #01 and #03 are my favorites.

Permanent Markers These are a must for doodling on surfaces like jeans, sneakers, or walls.

Other Options Ballpoint pens, colored pencils, felt-tip pens, mechanical pencils—whatever is within reach when the doodling urge strikes!

Gel Pens Gel pens will write on practically any colored paper. They also lay down super smooth lines. A set of multicolored pens is great to start. You can also add glittery or metallic pens for extra pizzazz.

Surfaces

Vellum Finish Bristol Board This is a smooth, white surface—my favorite for doodling.

Basic Copy Paper Use this for casual doodling or for working out ideas. It is inexpensive and usually thin enough that you can see through it to the underlying sheet. If I've worked out an idea on a piece of scrap paper, I might place it under a piece of copy paper so that I can trace over the design.

Ruled Notebook Paper Doodles look all the more "doodly" when they're scribbled on notebook paper. Doodles and notebook paper are a match made in heaven.

Kraft Paper Black doodles on Kraft paper look chic and sophisticated, especially when used as gift wrap.

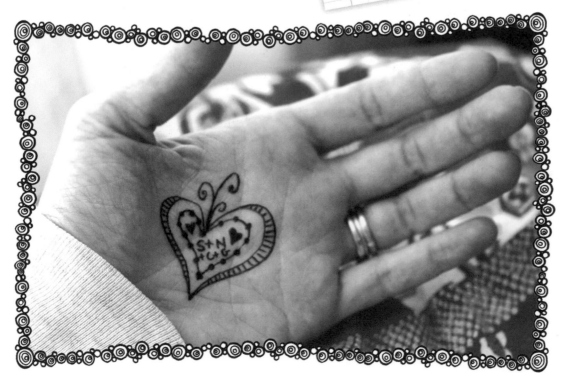

When doodle inspiration strikes, don't be picky about your surface. I have doodled on wood, ceramic, fabric, and even the palm of my hand!

Sparking Creativity

Some days, the creativity sparks fly; other days, the sparks are nowhere to be found. When that happens, turn to these fun exercises for endless ideas and inspiration!

The Mix n Match

On the opposite page, write an adjective, a verb, and a noun on the numbered lines under the appropriate columns. (I've added a few to get you started.) Then select three random numbers, which will be your key to unlocking a doodling prompt. For example, if your numbers are 7, 2, and 6, select the adjective on line 7, the verb on line 2, and the noun on line 6. Your doodling prompt? "Sparkly reading cookie!" If you select 5, 1, and 3, you get a "tiny singing tree." How lovely!

TIP
Doodling inspiration can come from the things you see or imagine. Doodles should be a spontaneous outward manifestation of what's on your mind. So draw when the spirit moves you, allowing your thoughts to guide you.

	Adjective	Verb + "ing"	Noun
1.	giant	singing	bird
2.	green	reading	house
3.	fuzzy	glowing	tree
4.	shiny	sleeping	baby
5.	tiny	painting	ball
6.	yummy	swinging	cookie
7.	sparkly	dancing	angel
8.			
9.			
10.			
11.			
12.			
13.			
14.			
15.			
16.			

The Connect Two Zoo

Create a numbered list of animals, naming as many as you can think of. (I've added a few to get you started.) Choose two random numbers from your list (no peeking first) and doodle the fantastical animal hybrid. For example, 2 + 7 = a dog/panda and 4 + 5 = a turtle/fish!

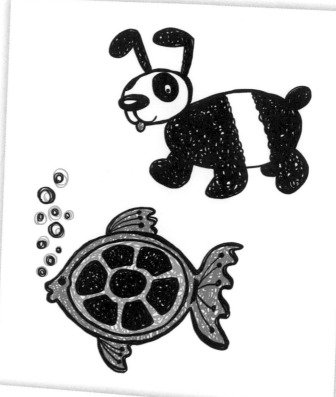

1. elephant
2. dog
3. giraffe
4. turtle
5. fish
6. raccoon
7. panda
8. parrot
9. monkey
10. swan
11.
12.
13.
14.
15.
16.
17.
18.
19.
20.

21.
22.
23.
24.
25.
26.
27.
28.
29.
30.
31.
32.
33.
34.
35.
36.
37.
38.
39.
40.

More Ideas

Getting Wordy

Make everyday language a source of art with the following ideas:
- Motivational phrase doodles are perfect for office walls.
- Humorous one-liners or knock-knock jokes can add personality.
- Classic quotations or unique catch phrases never fail.
- Doodles of dates, anniversaries, personal messages, and milestones make for original and sentimental keepsakes.

One Thing At A Time

Draw one object. It can be anything from a dog or cat to a star or rainbow. After you draw the first object, think of something that would be an odd or unlikely pairing with the first object and doodle it. Then, select a third object that wouldn't belong with the second object, and doodle it. The idea is to create a bundle of random objects. For example, if you start with a diamond, you might draw a hot dog, followed by a panda bear, and a grandfather clock. It's fun to think of ridiculously mismatched items. Before you know it, your creativity will be flowing again!

A Few Favorite Things

When all else fails, turn to your favorite things for inspiration: a special shirt, pretty wrapping paper, a trendy magazine, snuggly sheets, or even the packaging from a favorite snack! Use those items as a starting point for some doodles. For example, your favorite paisley shirt may inspire a patterned border, or the print on a beloved couch pillow may be the springboard for a doodled greeting card. Inspiration is all around. You know what you like, so steal some great ideas from your favorite things!

Borders and Flowers and Letters, Oh My!

You don't need much formal preparation to begin doodling, but getting your hand accustomed to loose, flowing movement will help your doodles look relaxed and natural. The next several pages feature a variety of commonly doodled elements. Use the open pages to practice drawing these, as well as to create your own designs! Start by practicing each of the patterns below in the spaces provided to get into the doodling groove.

Practice Here!

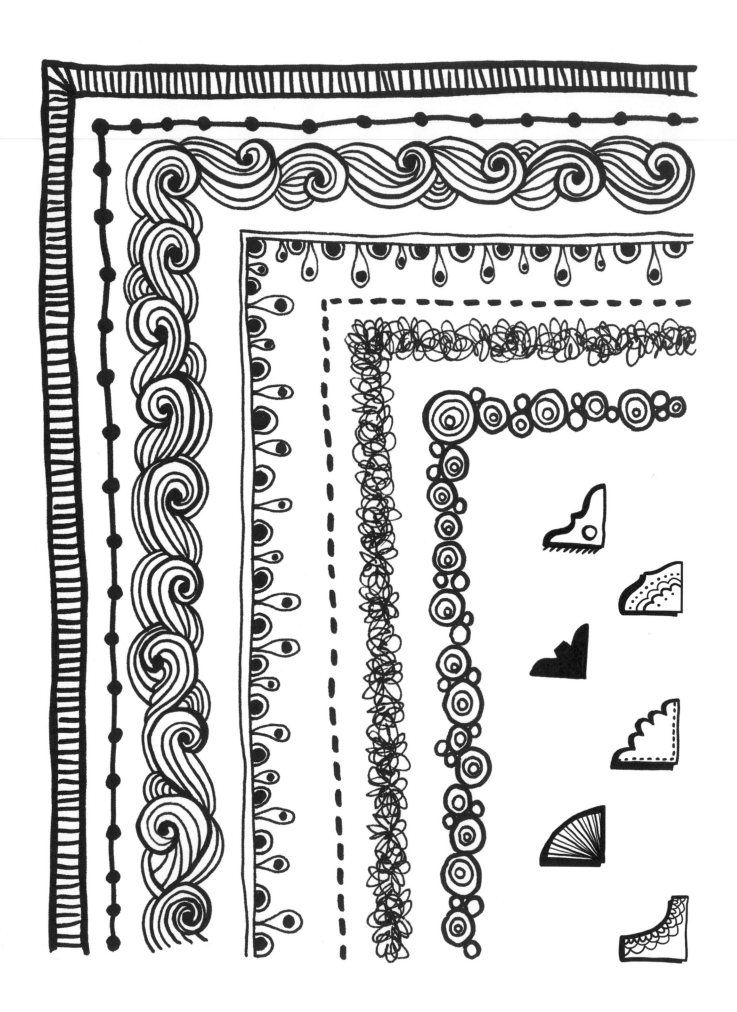

Practice Here!

Practice Here!

October

August

Xmas

November

December

Feburary

Questions

Valentine's day

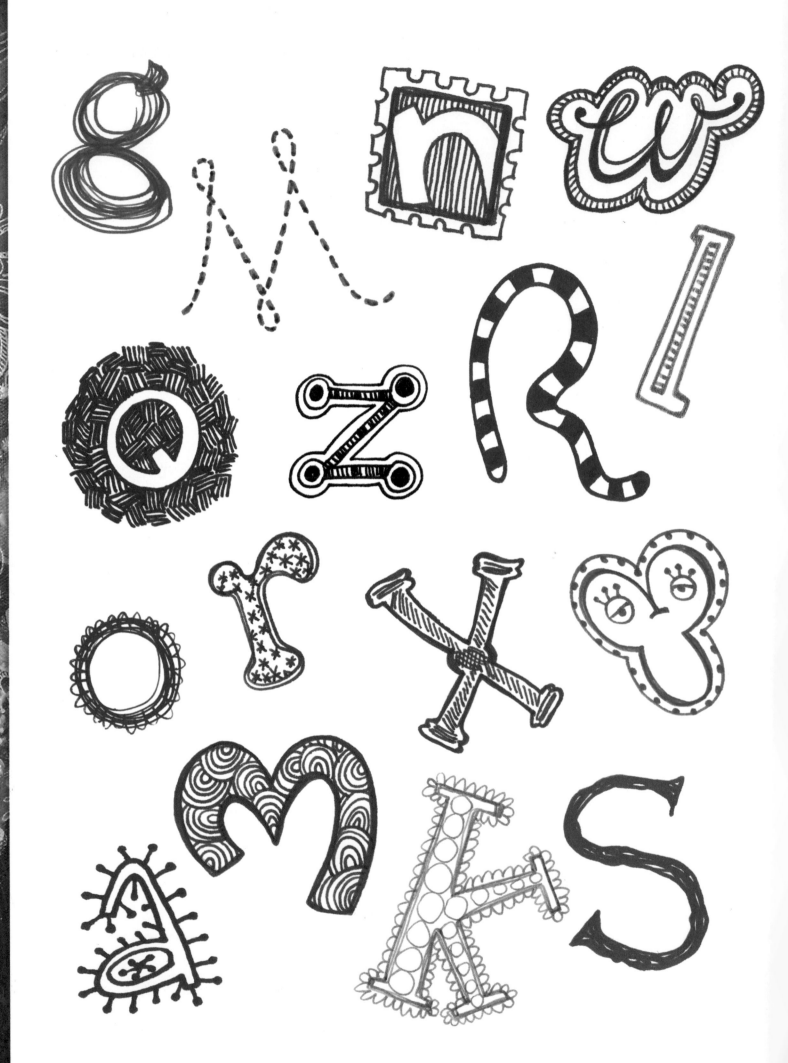

Practice Here!

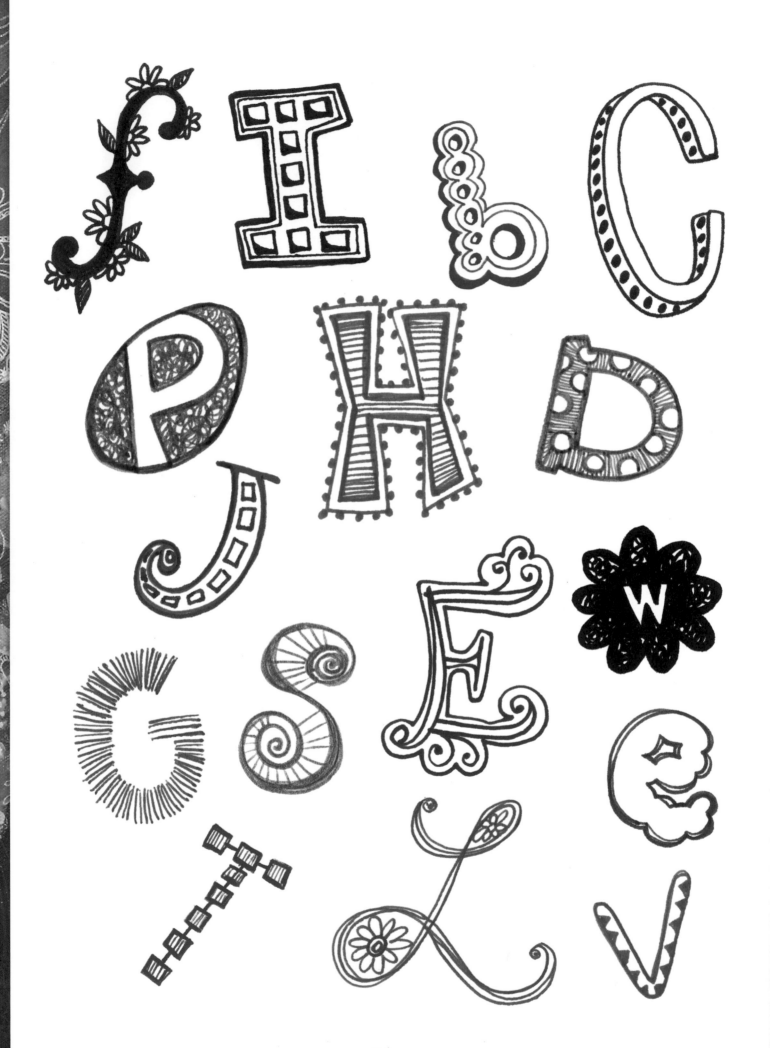

Practice Here!

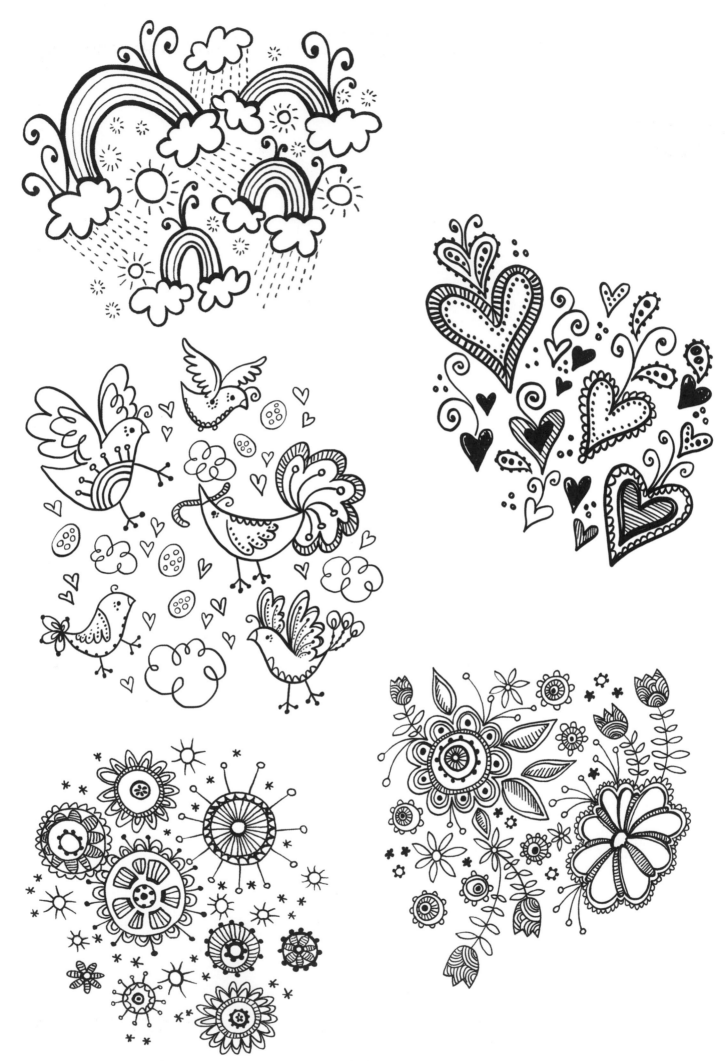

Practice
Here!

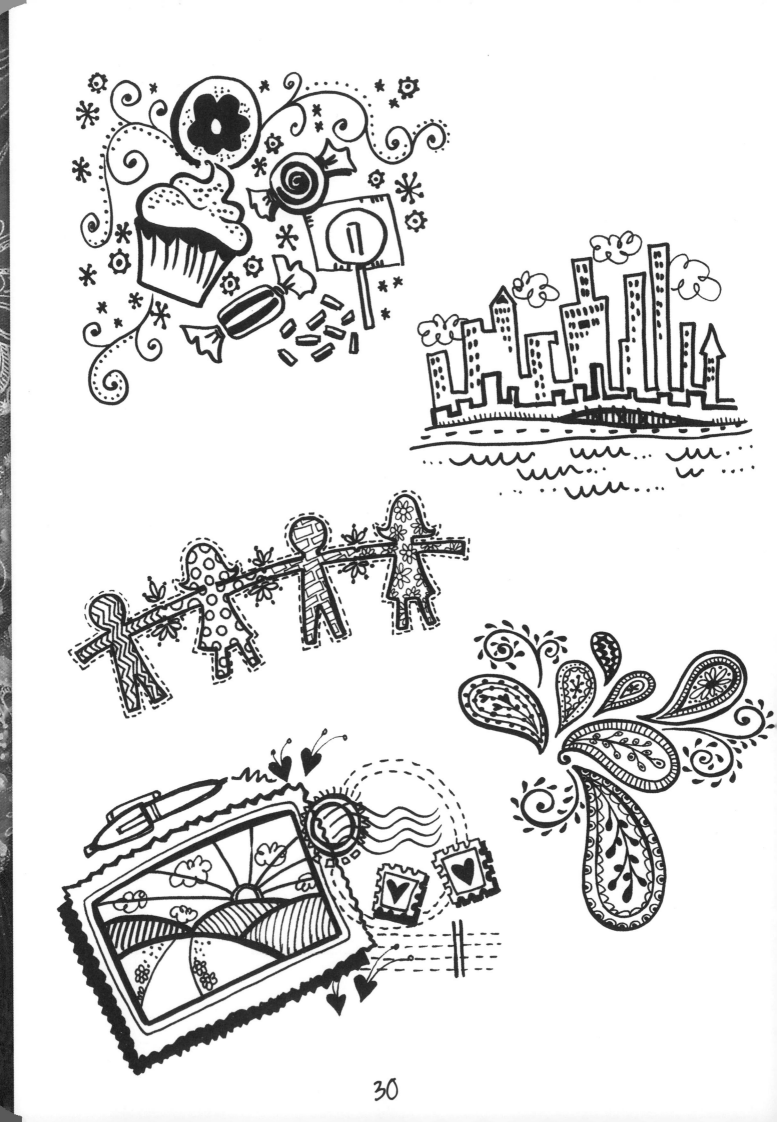

Practice Here!

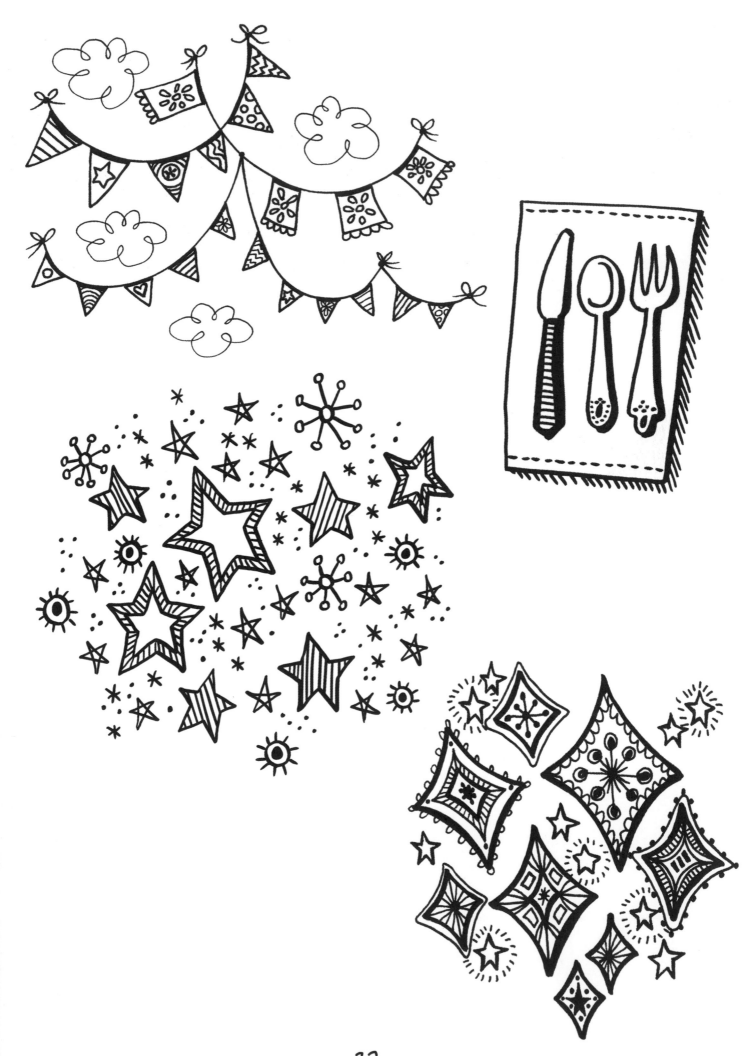

Practice Here!

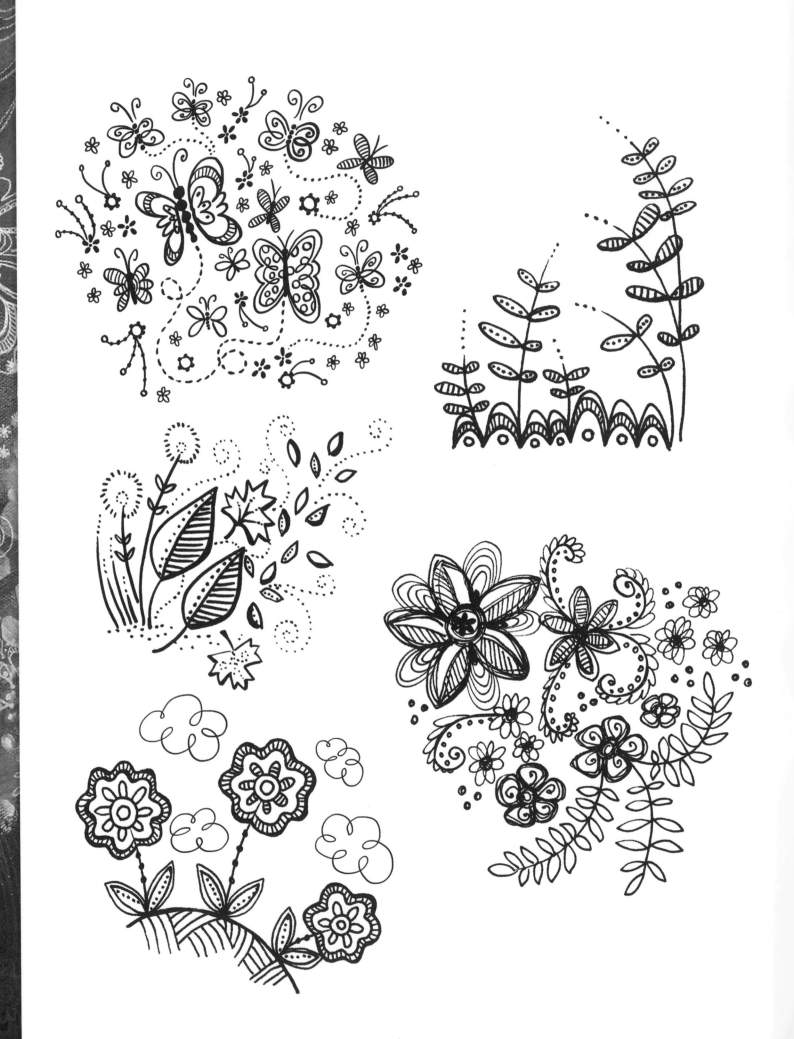

Practice Here!

Random Doodle

Grab the nearest book or magazine and open to a random page. Choose the first item or word you see and then challenge yourself to find inventive ways to doodle it on the opposite page. Be creative! The idea is to be spontaneous and to get comfortable with your doodling style.

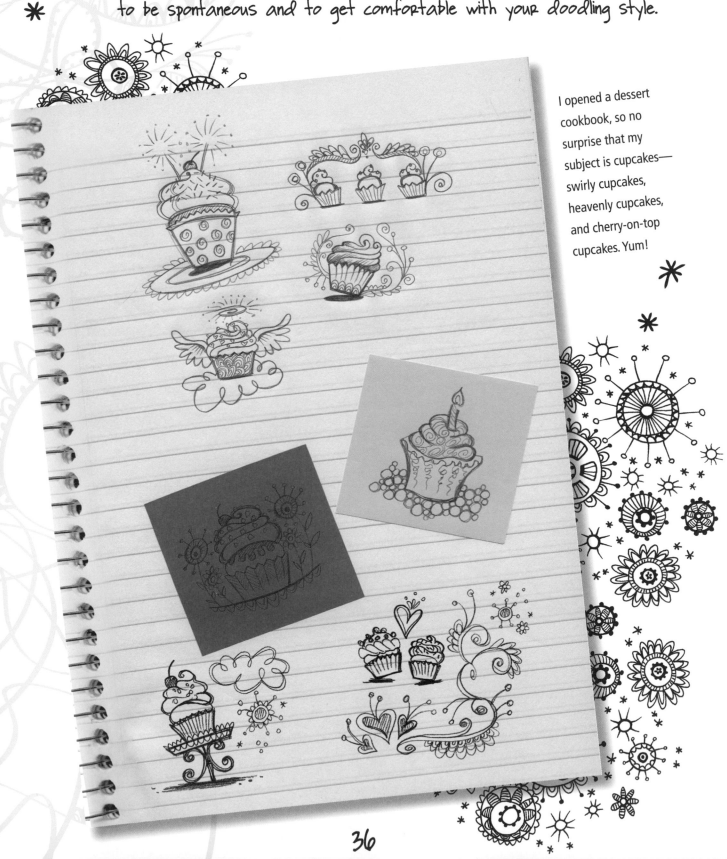

I opened a dessert cookbook, so no surprise that my subject is cupcakes— swirly cupcakes, heavenly cupcakes, and cherry-on-top cupcakes. Yum!

Practice
Here!

Experiment with Line Weights

Gather up three to five pens with different tip/nib sizes. On the opposite page in the top frame, draw a simple doodle using only one of the pens. In the bottom frame, draw the same doodle utilizing all of the pens. Notice how the heavier, thicker lines command attention in your doodle and give weight to the drawing. Both styles are useful depending on the outcome you hope to achieve.

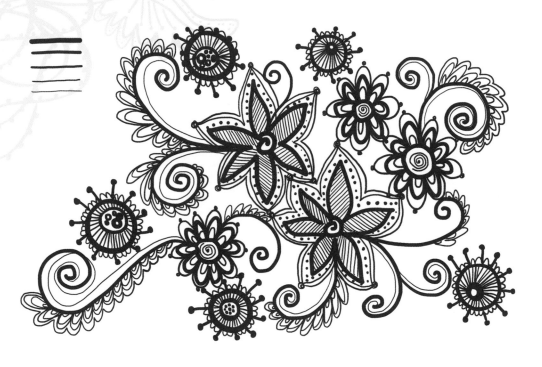

Draw the main elements of the design using the thickest line weight. Then add in a slightly thinner set of details, followed by another, and another until your tiniest details are complete in the thinnest line weight. Observe how using varying line weights gives your illustration a more dynamic look with more depth (top) than the drawing done in only one line weight (bottom).

Practice Here!

39

Easy-Peasy Doodled Gift Tags

These handmade tags add a personal touch to your gifts.
Make several at a time to keep with your gift-wrapping stash.

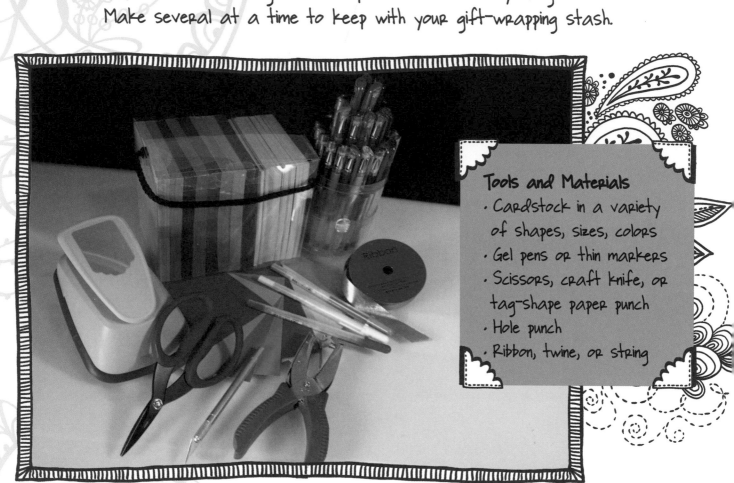

Tools and Materials
- Cardstock in a variety of shapes, sizes, colors
- Gel pens or thin markers
- Scissors, craft knife, or tag-shape paper punch
- Hole punch
- Ribbon, twine, or string

Step 1 Use the practice spaces on page 41-43 to work out some simple doodled patterns. Feel free to copy the ideas shown or create your own patterns. Use the space below to note your progress or to brainstorm ideas.

Notes:

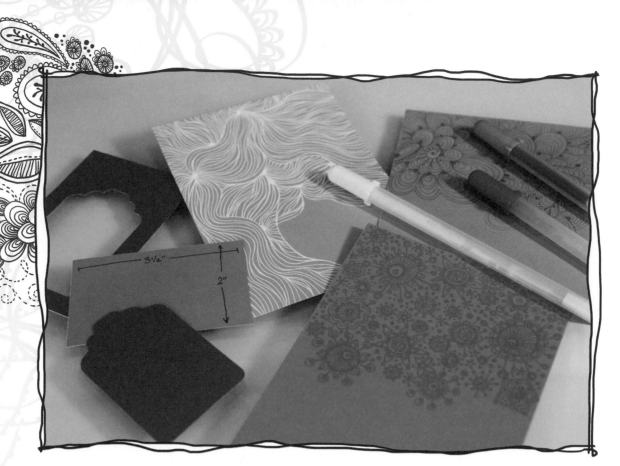

Step 2 When you are satisfied with your practice doodles, use a marker to doodle your cardstock until you've covered an area a little larger than a tag. Note that a standard business card (3-1/2" x 2") is the right size for a gift tag. Cut or punch a sample tag to reference as you go, so you'll know when you've doodled enough.

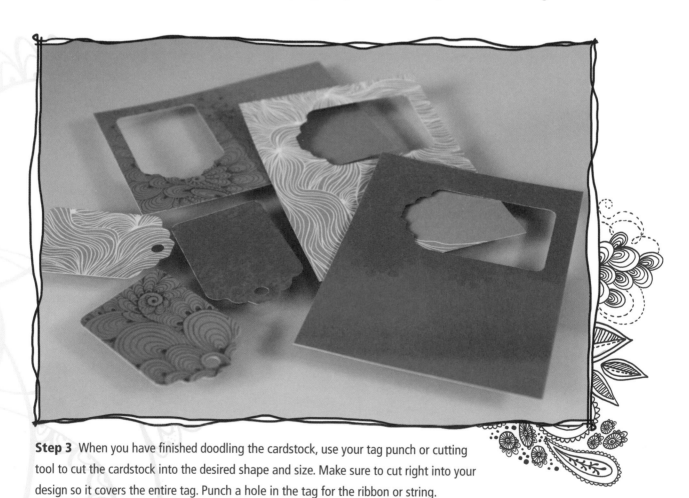

Step 3 When you have finished doodling the cardstock, use your tag punch or cutting tool to cut the cardstock into the desired shape and size. Make sure to cut right into your design so it covers the entire tag. Punch a hole in the tag for the ribbon or string.

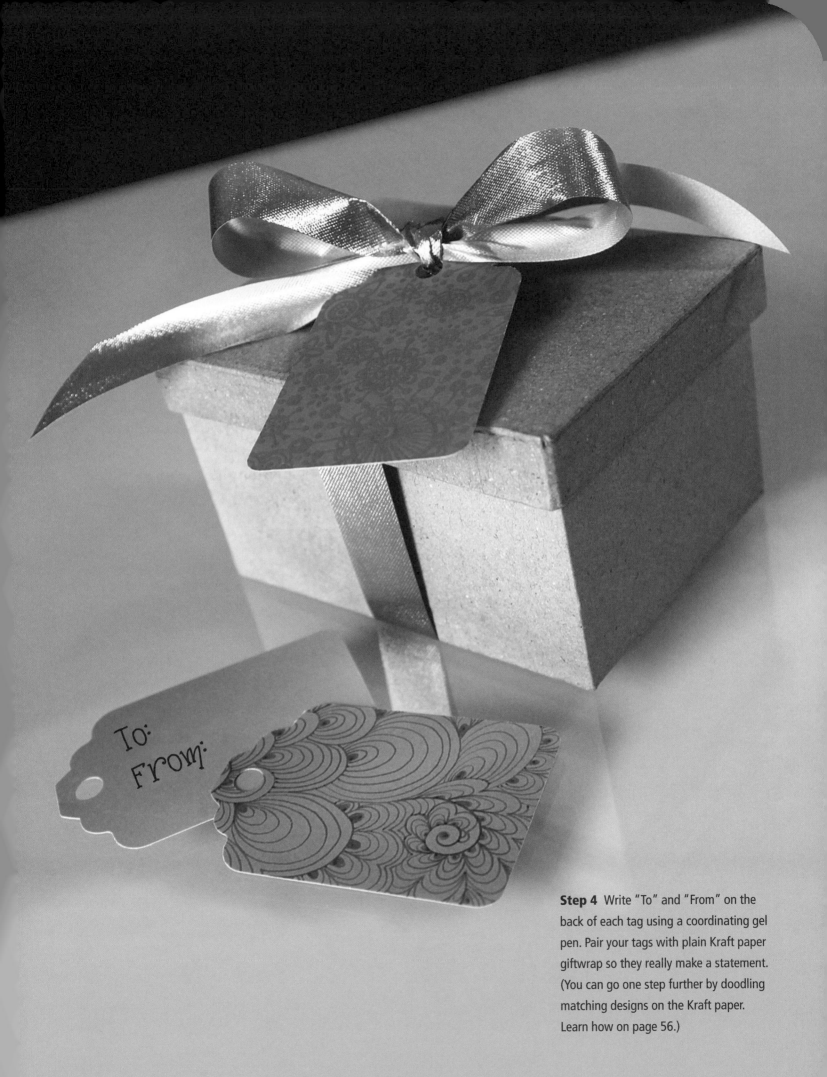

To:
From:

Step 4 Write "To" and "From" on the back of each tag using a coordinating gel pen. Pair your tags with plain Kraft paper giftwrap so they really make a statement. (You can go one step further by doodling matching designs on the Kraft paper. Learn how on page 56.)

Choose a Shape

Select a shape and then doodle patterns that only include that shape or parts of that shape. For example, the circular designs below include semi-circles and curves. Think of ways you can make an interesting pattern from one shape, and doodle it on the opposite page.

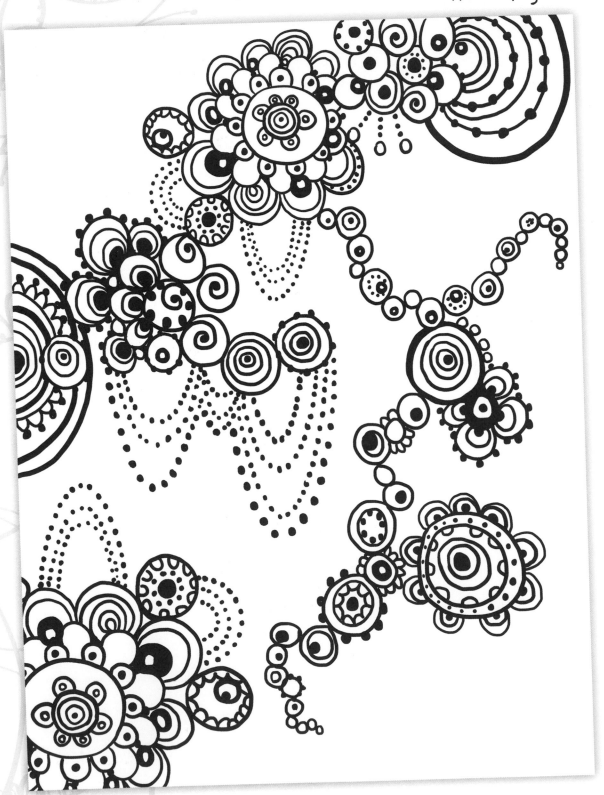

Practice Here!

Blind Doodles

For this exercise, you'll be doodling with your eyes closed. The objective is to keep a loose hand and "feel" your way through the doodle. This is a great way to start a drawing if you're having artist's block. I've never been disappointed with the results of an illustration that began as a blind doodle. (There's something to be said for happy accidents and unplanned ideas!) These drawings will be quirky and fun every time.

Dominant Hand

Using your dominant hand and a medium-point pen, draw a looping, freeform, curvy line without lifting the pen from the page. Stop whenever it feels right to stop. Open your eyes and take a look at what you've created. It might seem messy, but use your creative eye to transform it into an interesting design. Take a look at my blind doodle and then turn to pages 50–51 to practice your own.

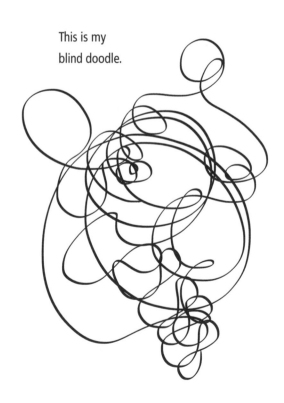

This is my blind doodle.

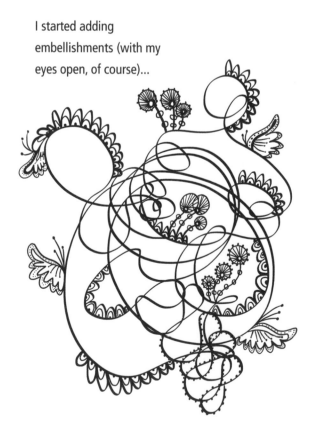

I started adding embellishments (with my eyes open, of course)...

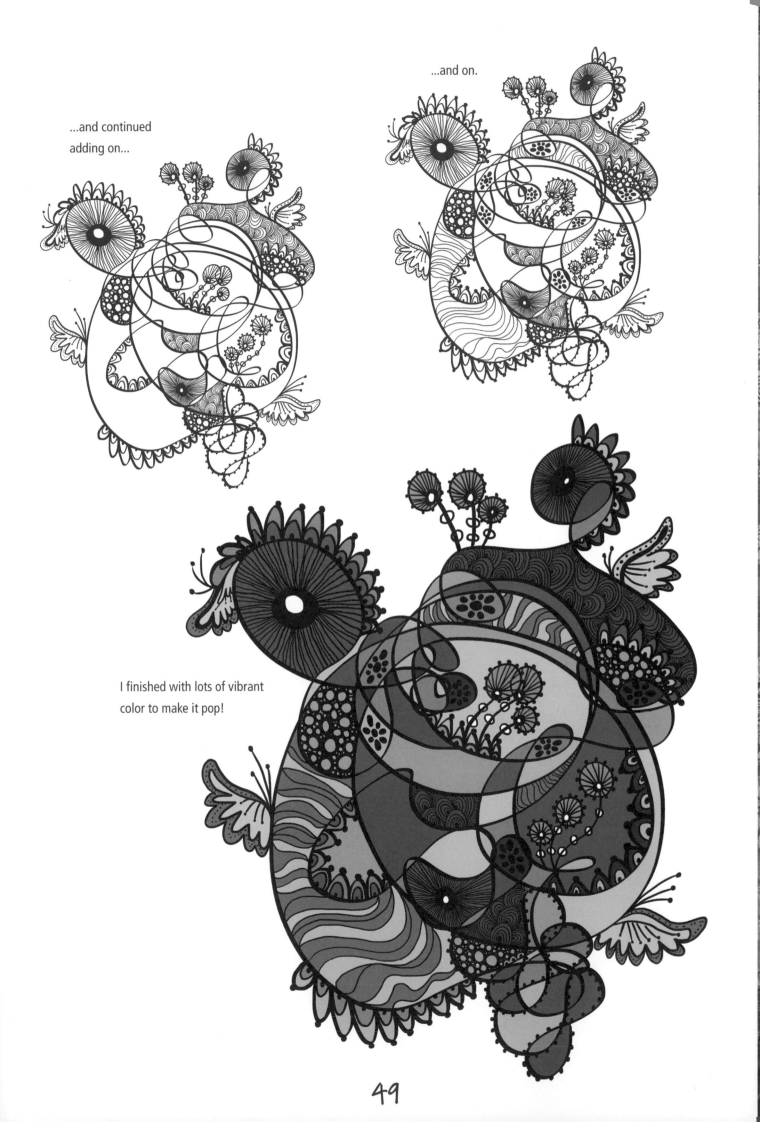

...and continued
adding on...

...and on.

I finished with lots of vibrant
color to make it pop!

Practice Here!

Non-Dominant Hand

Now create a blind doodle with your non-dominant hand, but use your dominant hand to embellish the design. You might find that drawing with your less-trained hand yields more spontaneous and unique results. That's ok. There are no rules, only creative outcomes! Check out my blind doodle, and then turn to pages 54-55 to try it out for yourself.

This is the blind doodle I created using my non-dominant hand. Not too shabby!

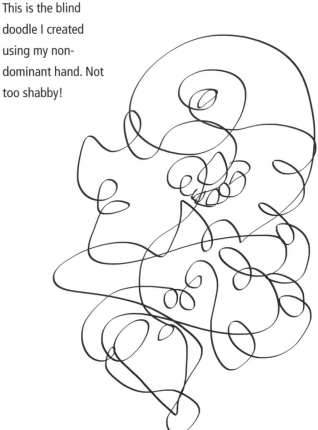

I added some design elements.

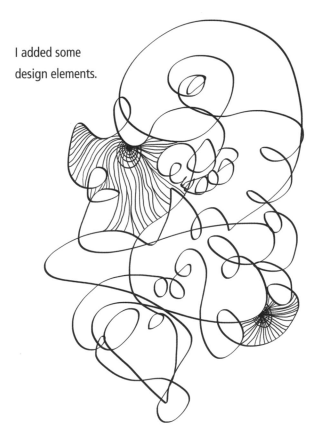

Then I doodled in some paisleys.

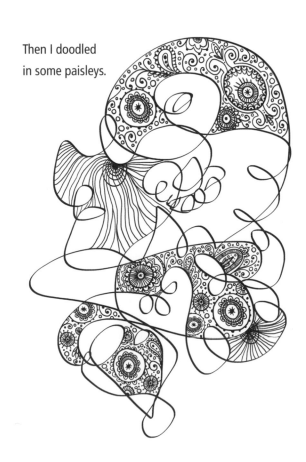

I added a bit more to fill in the empty spots.

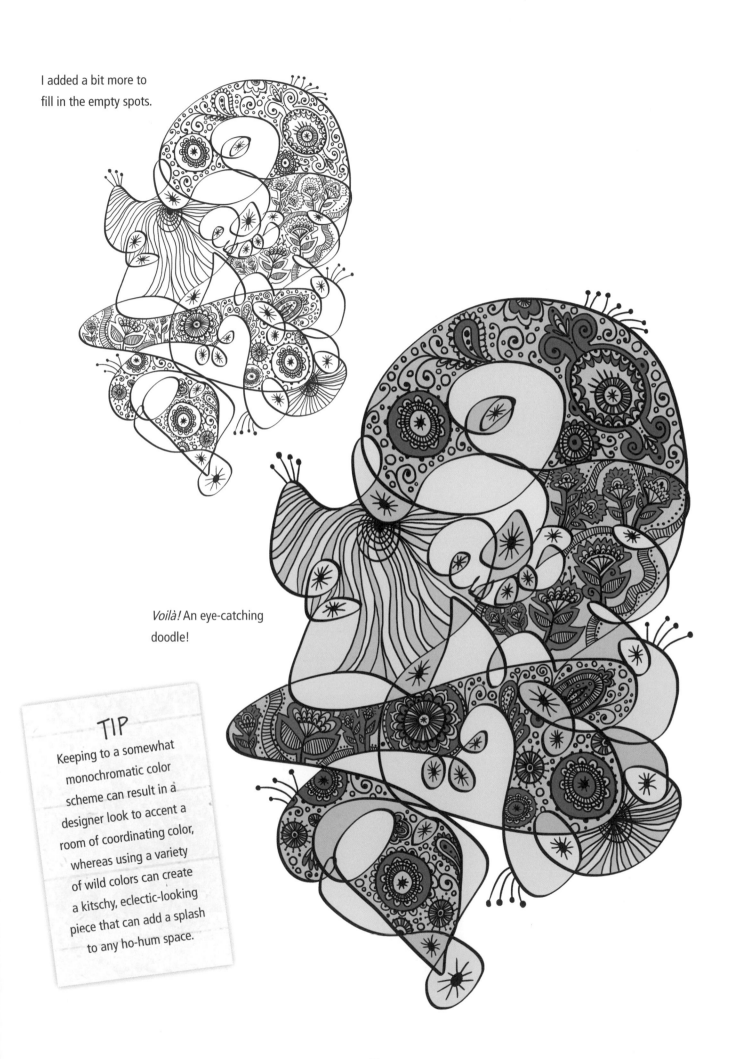

Voilà! An eye-catching doodle!

TIP

Keeping to a somewhat monochromatic color scheme can result in a designer look to accent a room of coordinating color, whereas using a variety of wild colors can create a kitschy, eclectic-looking piece that can add a splash to any ho-hum space.

Practice Here!

Doodle-Stamped Gift Wrap *

Making your own gift packaging is a cinch, and you'll never get stuck without paper or a decorative bag when you need one again!

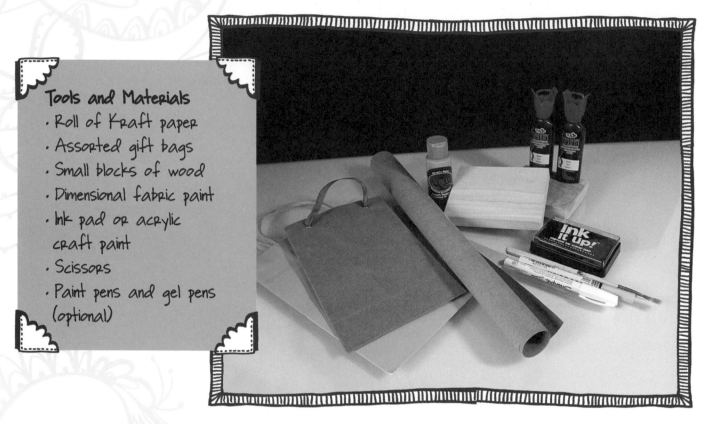

Tools and Materials
- Roll of Kraft paper
- Assorted gift bags
- Small blocks of wood
- Dimensional fabric paint
- Ink pad or acrylic craft paint
- Scissors
- Paint pens and gel pens (optional)

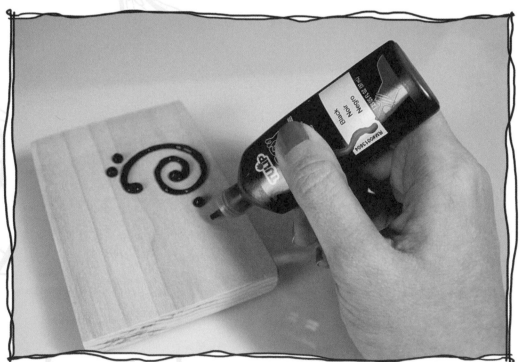

Step 1 Doodle a design onto a wood block with the dimensional fabric paint. Keep your design large and simple. Your stamp will work best if you build up the depth of the doodles so that you have a fairly deep relief. Be sure to keep all the doodles the same depth so that all parts of your design will touch down on the page when you stamp.

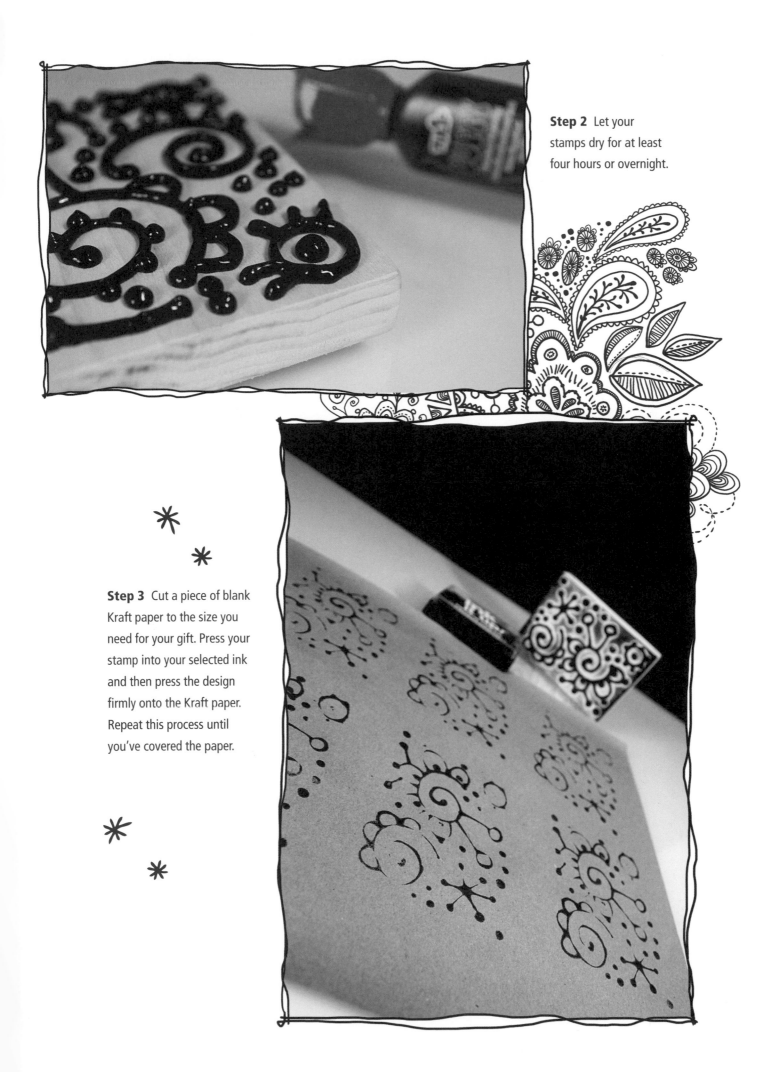

Step 2 Let your stamps dry for at least four hours or overnight.

Step 3 Cut a piece of blank Kraft paper to the size you need for your gift. Press your stamp into your selected ink and then press the design firmly onto the Kraft paper. Repeat this process until you've covered the paper.

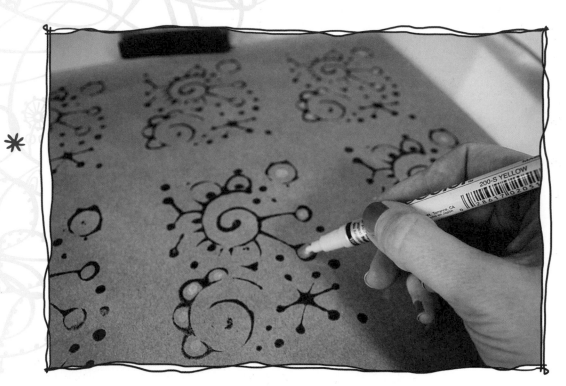

Step 4 To add more flair, use paint pens and gel pens to further embellish your designs. Allow your paper to dry completely before using it to wrap your gift.

TIP

To stamp on glossy surfaces, such as gift bags and traditional giftwrap, use acrylic craft paint instead of an ink pad. Acrylic paint won't bead up on the glossy surface like a water-based ink will. Simply use a small brush to apply a thin layer of paint onto some scrap cardboard, dip your stamp into it, and press the stamp to the desired surface.

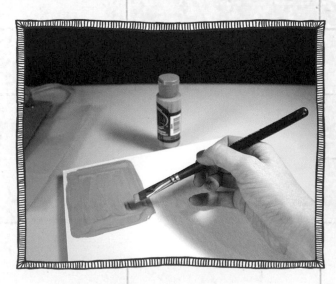

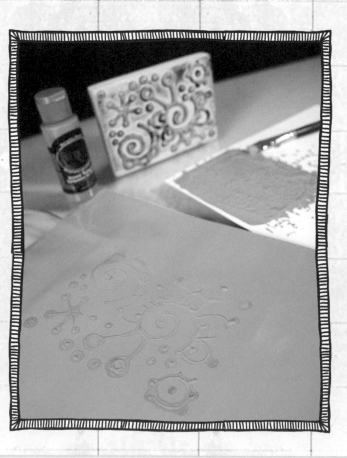

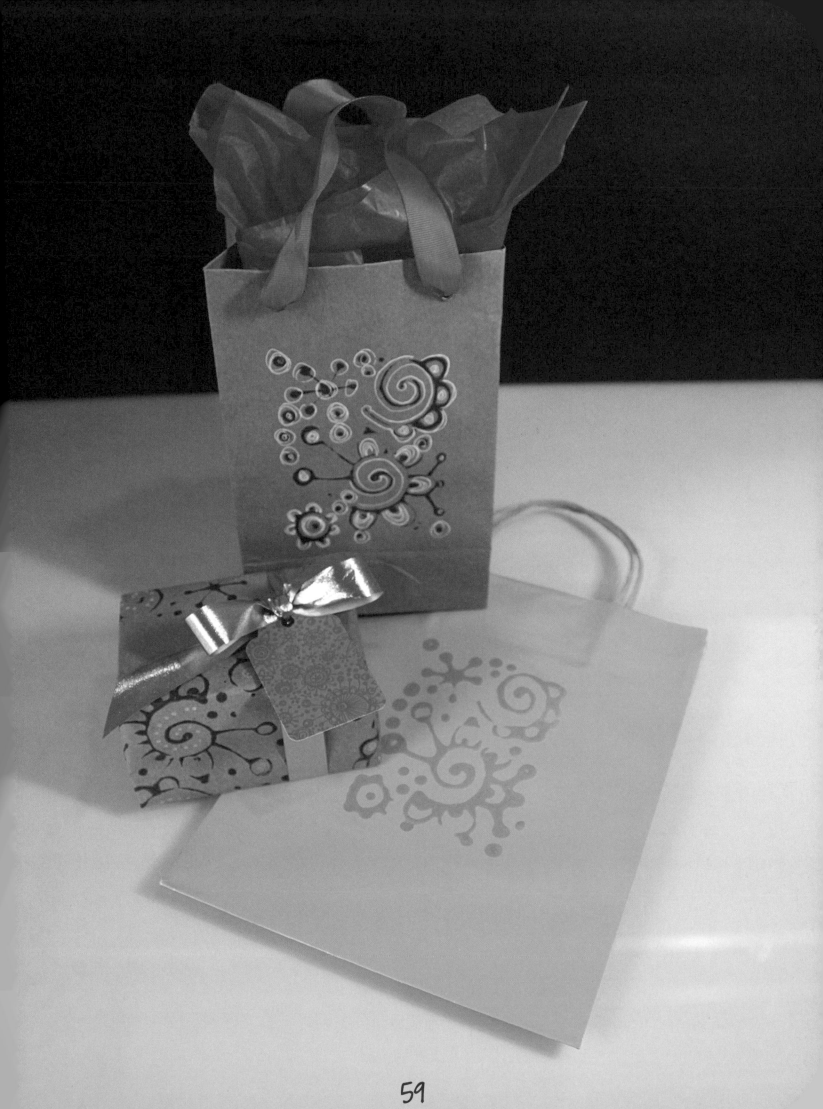

Nature Doodles

Select an item or scene from nature, such as a flower, plant, or meadow. Examine the shapes that make up your selected item and use them as inspiration to create a doodle on the opposite page. Whenever I find myself in a doodling rut, I look to the outdoors for inspiring bits of all-natural eye candy.

I chose lily pads and blossoms as inspiration. The curves of the almost heart-shaped leaves against the spiky flowers gave me some new ideas to add to my doodling repertoire.

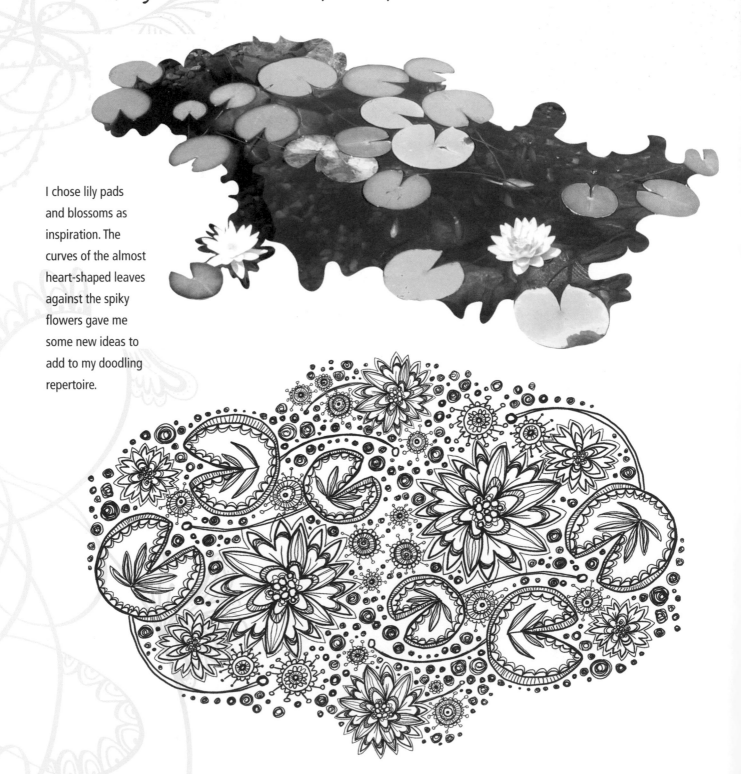

60

Practice Here!

A Fresh Perspective

When your artistic vision goes stale, these two exercises will help give your creativity a jolt!

Double Doodle

Enlist the help of a friend. Then grab some gel pens or markers in a variety of colors. Set a timer for five minutes, and start doodling in your favorite color. When the time expires, pass the doodle to your partner. Set the timer for another five minutes, and let your pal add to it using a different color. Continue to alternate for as long as you like, using a new color each time you switch. This is a great exercise for teaching you to let go and have fun with your doodling. Turn to page 66 to practice this exercise now.

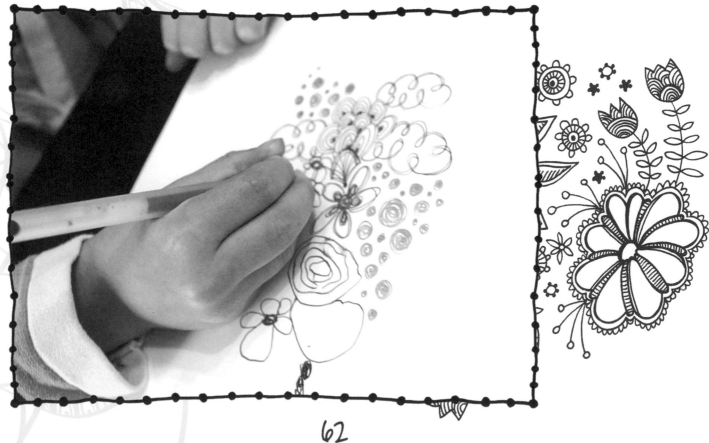

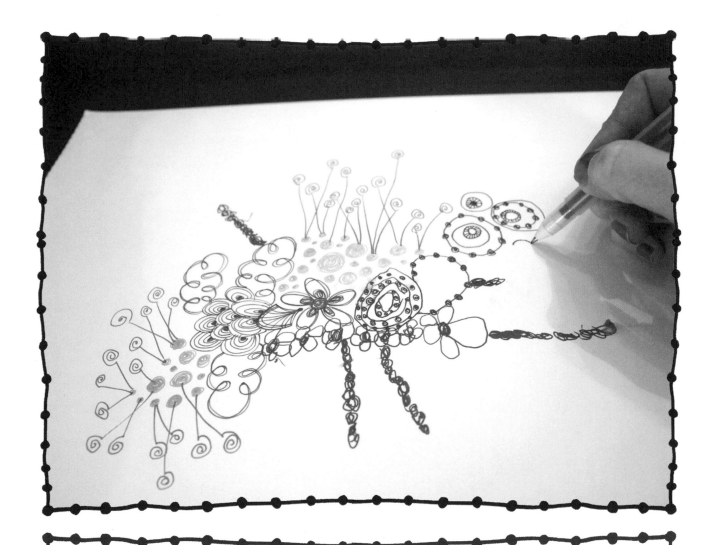

BONUS

The final artwork will be a great keepsake for you and your doodling partner. Be sure to make a color copy so each of you has a memento.

Topsy-Turvy Doodle

Have a selection of multicolored pens or markers on hand; then set your timer for 10 minutes and begin doodling. When the time is up, rotate your drawing 90 degrees, reset the timer, change colors, and continue doodling. Continue this process until you feel the work is complete. This continual change in perspective keeps you on your toes. (You may decide to do all your doodles this way in the future!) The finished drawing will have an inherent dynamic look from all that spinning. The ultimate goal of changing perspectives is so that you can "see" your work in a different way. Turn to page 67 to practice this exercise now.

64

Doodled Photograph Art Installation ✱

Add personality and charm to a collage of your favorite photographs with these doodling ideas!

Tools and Materials

- 1/2" thick wood board cut to your preferred size
- Black paint or chalkboard paint
- 7 to 12 black-and-white or colored photos of a favorite subject
- Rubber cement or acid-free double-stick tape
- Gel pens, opaque paint pens, scrapbooking pens, or any art pen for glossy surfaces
- Black fine-point markers
- Acid-free adhesive photo dots
- Double-stick tape
- White or colored cardstock
- Ruler
- Scissors or craft knife

Step 1 Paint your board with your black paint or chalkboard paint, and set aside.

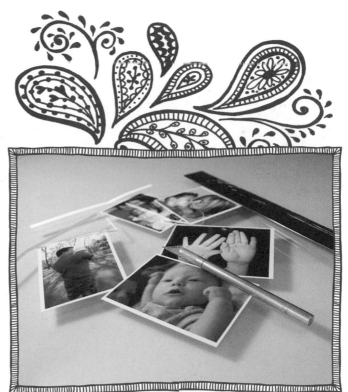

Step 2 Make prints of your selected photos—do not use the originals. You can use varying sizes or keep all photos the same size. I did this on my home printer, but a printing or copy shop can do the job if you don't have access to a photo printer.

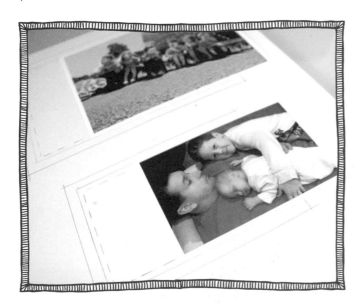

Step 3 Create photo "frames" for two or three of your photographs out of the white cardstock, making sure that the cardstock pieces are slightly larger than the photographs. For a 4"x 6" photo, for example, measure an area of 4-3/4" x 6-3/4" on the cardstock, marking it off lightly in pencil. Next, place your photograph in the center of the outline and use your pencil to lightly trace around it. Move the photo to reveal the outline. Now measure 1/4" in from the photo outline, marking off the area with dashes around all four sides. Repeat this process for your other frames.

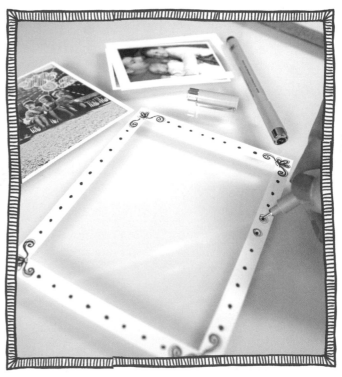

Step 4 Use a craft knife to cut around the interior dashed outline. Then use your scissors to cut around the outermost pencil outline to reveal the frame. In the example above, our frame should have a 1/4" overlap around all four sides of the photo. Use a fine-tipped art marker or pen to doodle your frames, as desired.

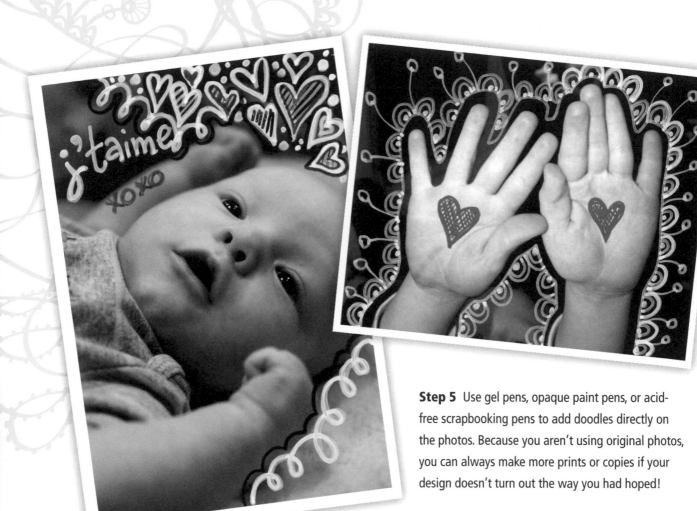

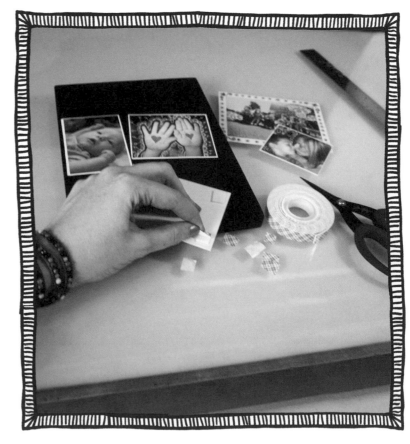

Step 5 Use gel pens, opaque paint pens, or acid-free scrapbooking pens to add doodles directly on the photos. Because you aren't using original photos, you can always make more prints or copies if your design doesn't turn out the way you had hoped!

Step 6 Arrange your photos on your painted board until you are happy with the layout. Then use the rubber cement or acid-free double-stick tape to adhere them to the surface. Add dimensional dots to the back sides of some photos to make your collage pop.

70

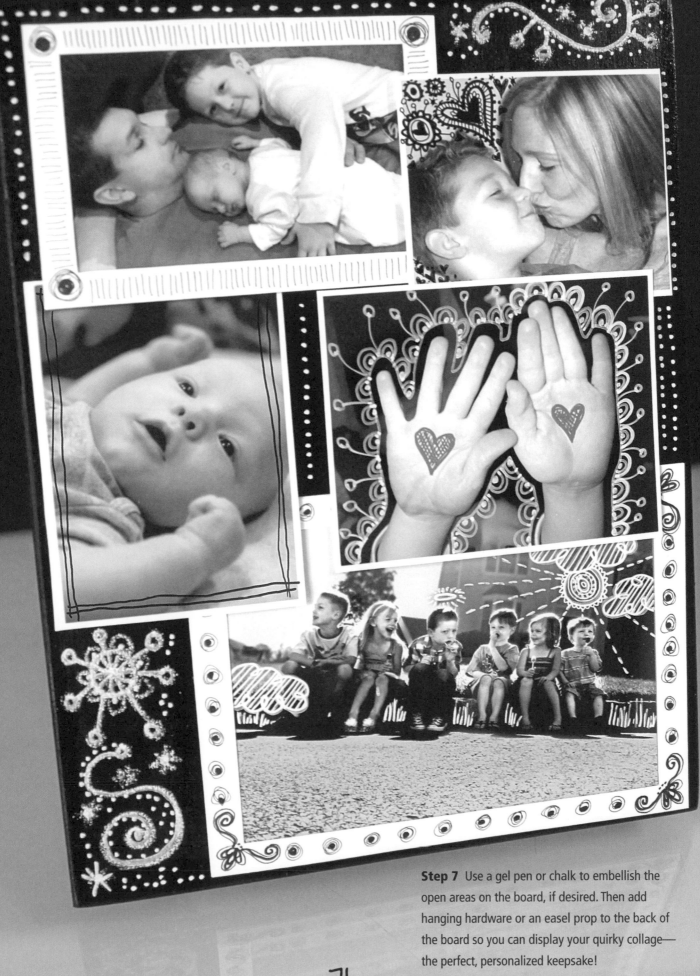

Step 7 Use a gel pen or chalk to embellish the open areas on the board, if desired. Then add hanging hardware or an easel prop to the back of the board so you can display your quirky collage— the perfect, personalized keepsake!

71

Fun with Letters & Numbers

Nicknames, quotes, meaningful dates, notes of congratulations, and birthday wishes are all made up of numbers and letters, and they are some of the best things to doodle. Doodle the alphabet and numbers one through ten without repeating the same design style twice. If you get stuck, try one of the following: 1) Brainstorm different adjectives, such as "girly," "strong," "sketchy," or "modern," and then draw your character to fit that description. 2.) Draw a shape, such as an oval or square, around a letter or number; then fill in the shape around the character with color or texture, but leave the interior of the character empty. This is referred to as negative space in the fine-art world. (See my doodled N, S, and 6 for examples of this.) Practice a variety of different styles and creations on the opposite page to serve as reference for future projects!

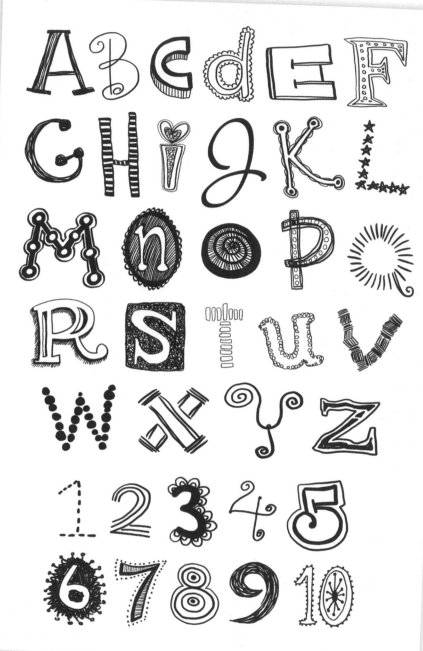

Practice Here!

Compositions

Number Composition

Create a sequential, vertical composition using numbers. Each number should have a unique shape and form. The idea is to nestle these shapes together into a tight, artistic arrangement. Use the opposite page to practice doodling a number composition following the steps below.

◄ **Step 1** Starting near the top left of the page, doodle a number 1.

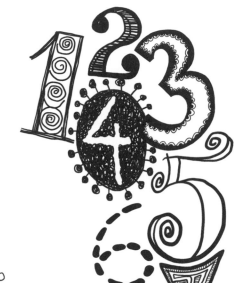

◄ **Step 2** Gradually add doodled numbers in sequence down the page with thoughtful placement. Try not to repeat a doodle style more than once.

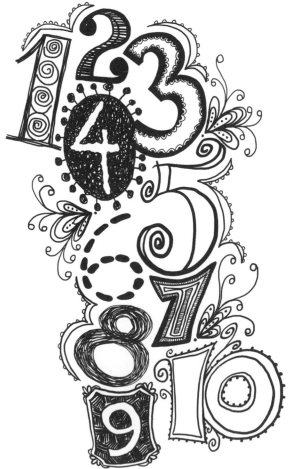

◄ **Step 3** Once all of the numbers are complete, go back and fill in any gaps and spaces with fun flourishes.

Practice Here!

Letter Composition

The objective for this exercise is to create a clustered composition using a single letter (or the initial of a special person) and a themed grouping of doodles to embellish it. You might select items that start with that letter or perhaps doodle the favorite things of the person whose initial you choose. Use the opposite page to work out your ideas.

BONUS
Add color and place in an appropriate-size frame for an adorable gift.

◀ **Step 1** Be creative with the placement of the embellishments, and utilize the shapes and spaces of your base letter.

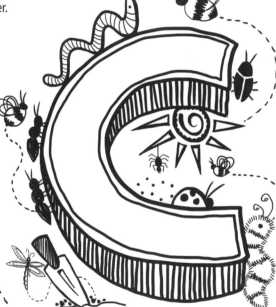

◀ **Step 2** Start with large primary elements; then add a second layer of mid-sized elements

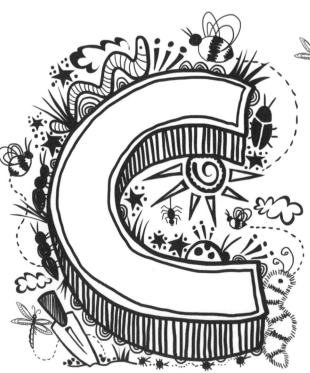

◀ **Step 3** Finish with small details and "filler designs," such as the stars and dots shown in the example.

Practice Here!

Step-by-Step Project #4

Special Occasion Doodles

Kissin' Tree Anniversary Art

For an extra special touch on your anniversary or Valentine's Day, nothing beats a handmade present.

Tools and Materials

- Heavyweight pastel paper or craft paper in two colors
- Plain tracing or typing paper
- Low-tack spray adhesive
- Pencil or pen
- Craft knife
- Cutting surface, such as self-healing cutting mat or tempered glass
- Foam adhesive mounting tape
- Ruler
- Appropriately sized frame and mat
- Foam core and hot glue gun (optional)

Step 1 Align your mat over the plain typing paper. Mark your doodle design area by using a pencil to lightly trace around the interior of the mat onto the paper.

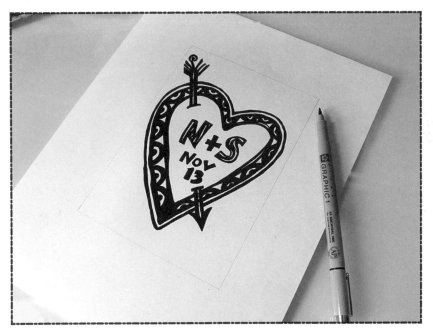

Step 2 Doodle a heart inside the design area; then doodle the initials of a couple and a special date inside the heart.

Step 3 Spray the backside of the doodle with the low-tack adhesive and gently press to one sheet of the heavyweight paper.

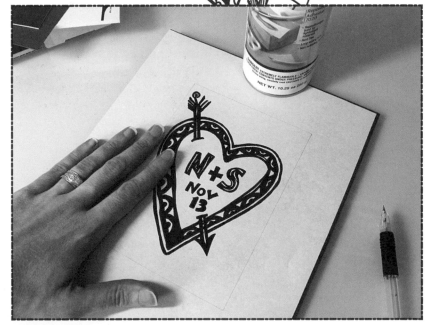

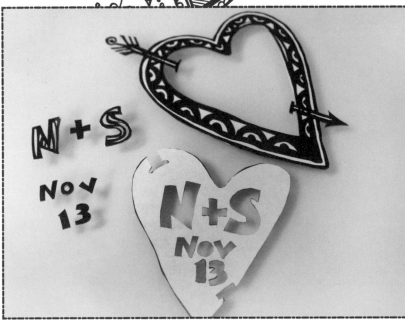

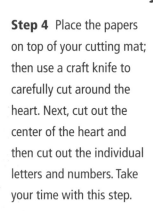

Step 4 Place the papers on top of your cutting mat; then use a craft knife to carefully cut around the heart. Next, cut out the center of the heart and then cut out the individual letters and numbers. Take your time with this step.

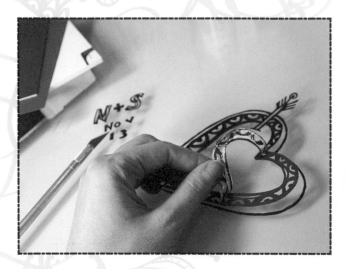

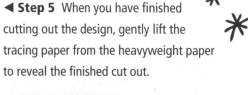

◀ **Step 5** When you have finished cutting out the design, gently lift the tracing paper from the heavyweight paper to reveal the finished cut out.

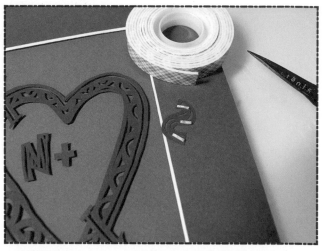

▶ **Step 6** Trim your second sheet of heavyweight paper to fit the mat and frame. This will be your background. Place the mat on top of the background paper to serve as a guide. Add small bits of foam tape to the back of your cutout and then affix it to the background. The small pieces of tape will create a "floating" effect. Foam tape varies in thickness, so try to find one that will not cause your art to compress against the glass. If this does happen, adhering thin foam core strips on the outer back edges of the mat with hot glue will create a little open space between the glass and the art. This will also enhance the floating effect.

▶ **Step 7** Assemble the artwork in the frame.

TIP
When sketching your artwork, stick to solid shapes or work at a level of detail that matches your skills with the craft knife. This will make cutting out the shapes easier.

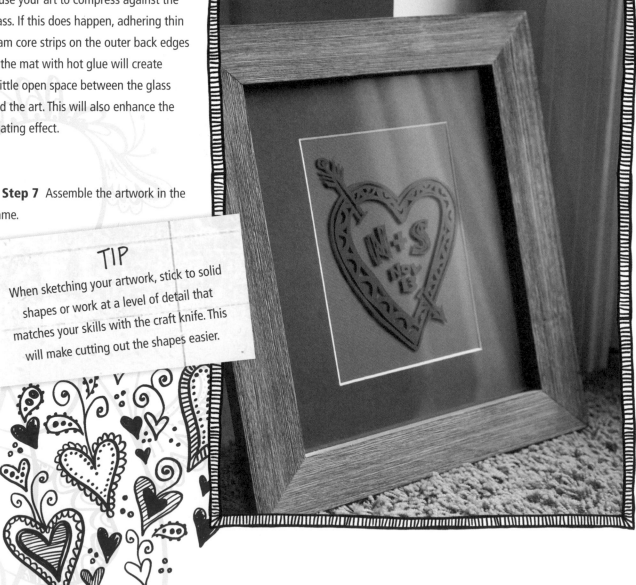

Birthday Banner

Start a new birthday tradition with this handmade birthday banner, which you can re-use each year by simply replacing the numbers.

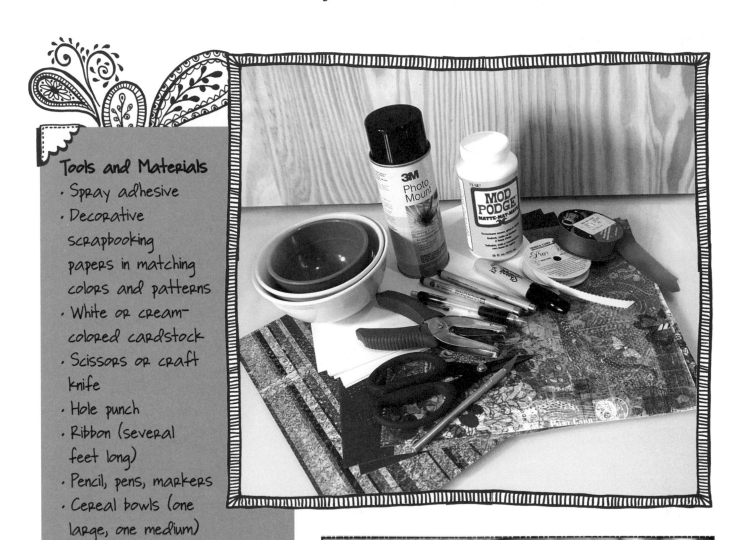

Tools and Materials

- Spray adhesive
- Decorative scrapbooking papers in matching colors and patterns
- White or cream-colored cardstock
- Scissors or craft knife
- Hole punch
- Ribbon (several feet long)
- Pencil, pens, markers
- Cereal bowls (one large, one medium)
- Drinking glass

▶ **Step 1** Determine how many circles you will need to create. You will need one large, one medium, and one small circle per each letter and number in the banner. Using the bowls as stencils, trace the large circles on one color or pattern of decorative paper, and then trace the medium circles onto another color or pattern of decorative paper. Use the drinking glass to trace the smallest circles onto the cardstock.

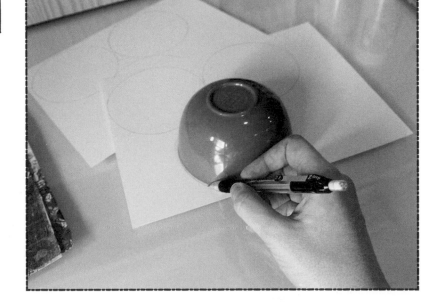

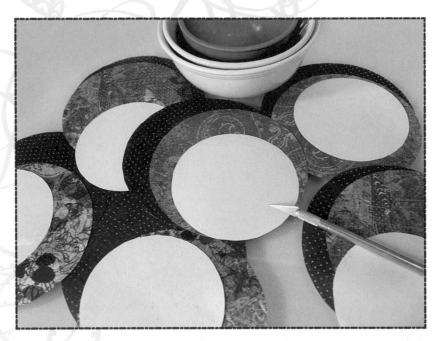

◀ **Step 2** Use scissors or a craft knife to cut out all of the circles from the paper and cardstock.

▶ **Step 3** Glue each set of circles together as shown using the spray adhesive.

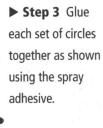

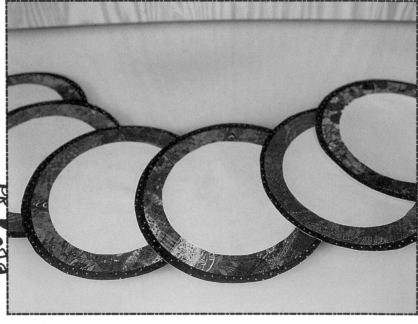

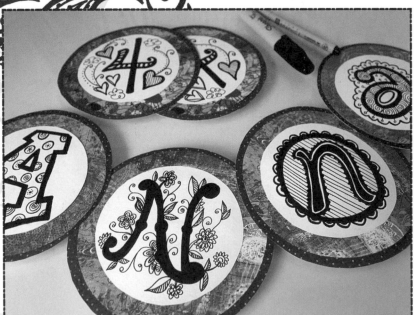

◀ **Step 4** Doodle one letter and one number per each circle. Be creative! Use swirls, polka dots, stripes, and hearts to embellish your designs. Try not to repeat the same style twice.

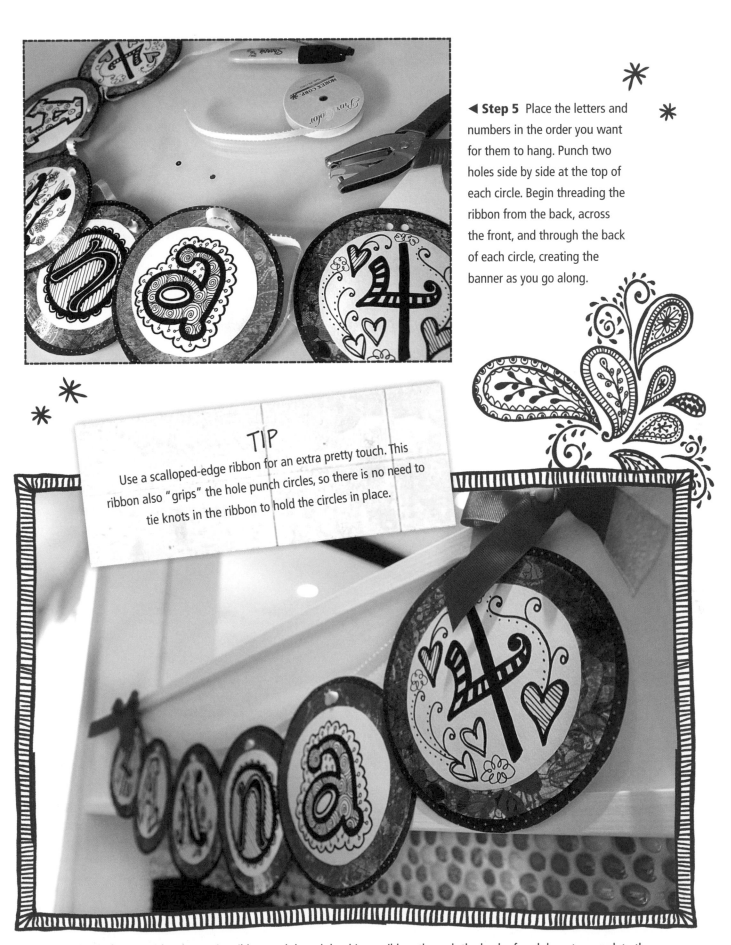

◄ **Step 5** Place the letters and numbers in the order you want for them to hang. Punch two holes side by side at the top of each circle. Begin threading the ribbon from the back, across the front, and through the back of each circle, creating the banner as you go along.

TIP

Use a scalloped-edge ribbon for an extra pretty touch. This ribbon also "grips" the hole punch circles, so there is no need to tie knots in the ribbon to hold the circles in place.

Step 6 Tie bows from a wider, decorative ribbon and thread the thinner ribbon through the back of each bow to complete the banner. Now it's ready to hang!

Space Out!

True, doodles are freeform by nature. But if you are looking to amp it up and make truly artistic doodles, there are some techniques that will never fail. First, it's all about spatial relationships. How far apart are you drawing repeating lines and objects? Is there a flow? Does your doodle keep the eye moving around the page? Is your doodle variable and organic or symmetrical and stiff? Do you have a balance of tightly spaced lines that read as darker and heavier, as well as more broadly spaced lines that read as lighter and airier? Review the following tips and examples provided; then use the opposite page to practice!

· Create varying spaces between curves, and make use of varied line weights to give more visual punch where you want it.

· Create subtle space variations in vertical line patterns. Instead of keeping the lines perfectly parallel, allow the curves to almost touch at times, playing with the size and shape of the unused spaces between them.

· Build families of like designs, each with slightly varied concentric line patterns. Space those objects in tight clusters or loose bunches, and note the effect.

· Stand back from your drawing often to see which areas are looking heavy and overly detailed and which might need more "oomph."

Practice Here!

Rhythm & Repeat

Repeat Yourself

You can't go wrong with a repeating motif, especially when it revolves around a theme. Repeating similar designs lends cohesiveness to your art. In this doodle, I've drawn the same basic bird several different ways and in various sizes. The result is a family of birds that resemble each other, but no two are exactly alike. (Just like a real family!) Review the steps below; then turn to pages 88-89 to practice your own repeating motif.

Step 1 Draw one little bird (or other motif of your choice).

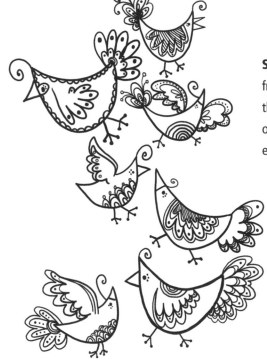

Step 2 Give the bird some friends and family, keeping the same basic shape and only changing the sizes and embellishments.

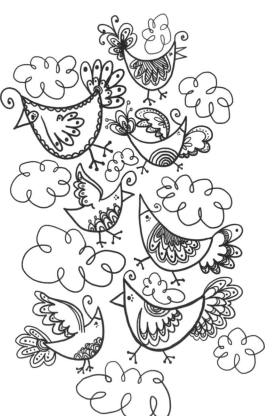

Step 3 Once you have a happy little cluster, fill in some of the open spaces with one or two coordinating design elements.

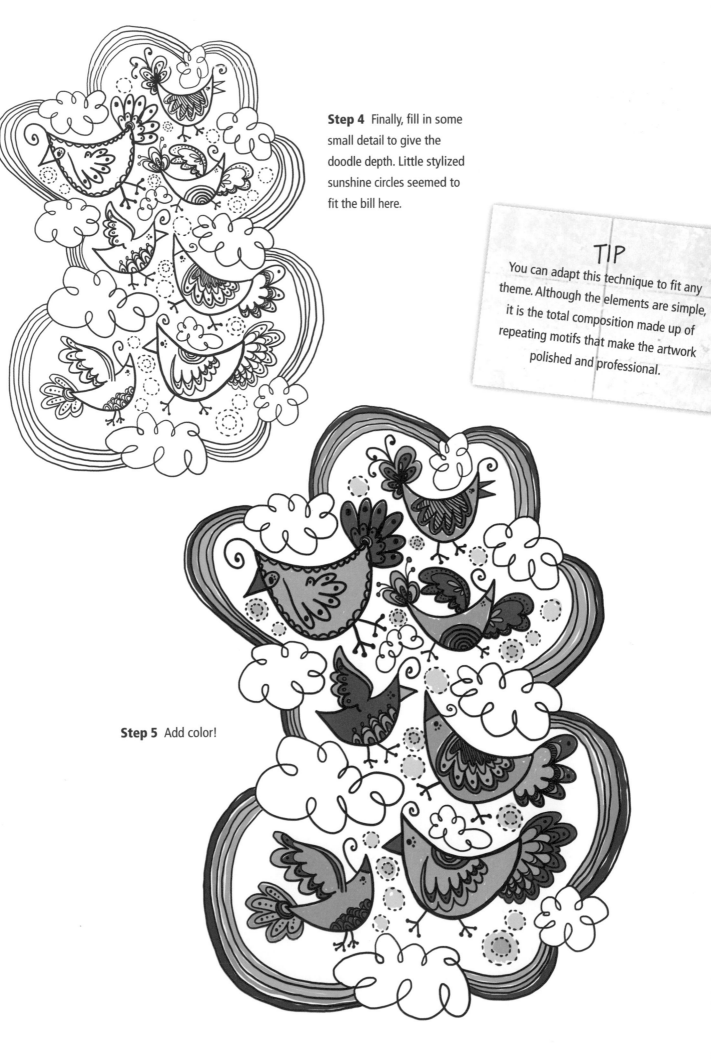

Step 4 Finally, fill in some small detail to give the doodle depth. Little stylized sunshine circles seemed to fit the bill here.

Step 5 Add color!

TIP

You can adapt this technique to fit any theme. Although the elements are simple, it is the total composition made up of repeating motifs that make the artwork polished and professional.

Get Some Rhythm

Rhythm isn't just for dancing! It's an important part of a good composition. Does your drawing have a nice balance of large and small, dark and light, curves and angles? All drawings don't need to have all of these elements, but they are good things to keep in mind. I often examine my drawings to see if they need additional contrast, larger objects to balance out smaller details, or more white space. On the opposite page, practice rhythm, using the example below as a guide.

Step 1 Draw a variety of large and small "baby onion" shapes. Add interior lines in varied weights, paying attention to developing a rhythm in your spacing.

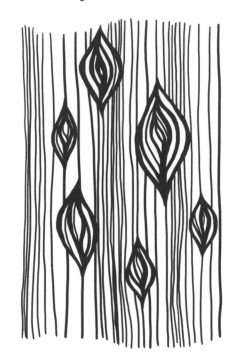

Step 2 Add a background of imperfect and slightly wavy vertical lines. Vary the distance between one line and the next. Trust your instincts to tell you when the lines should be spaced closer together or farther apart.

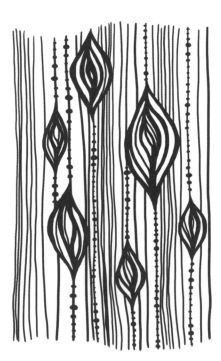

Step 3 Add a "rhythmic" series of dots along some of the vertical lines. These dots can vary in size, from large to small to large again. Think of waves as they crash on the beach in steady rhythm.

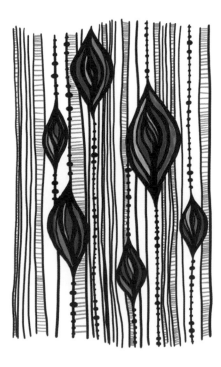

Step 4 Finally, add colored horizontal lines between some of the vertical lines. Then add a contrasting color scheme in the larger onion shapes to set them apart and punch up the design.

90

Practice Here!

91

Family Heirloom Handprint Doodle

Freeze a moment in time for your family! Take some snapshots as you work on this project to tuck into the back of the picture frame. It will be like a time capsule years later as you reminisce about your quality time together.

Tools and Materials

- Vintage-looking frame
- Black poster board cut to size for your frame
- Newspaper
- Mod Podge (matte finish)
- Various fine-tip black permanent ink pens
- Broad tip black marker
- White gel pen
- Watercolor paints and paintbrush
- Paper towels

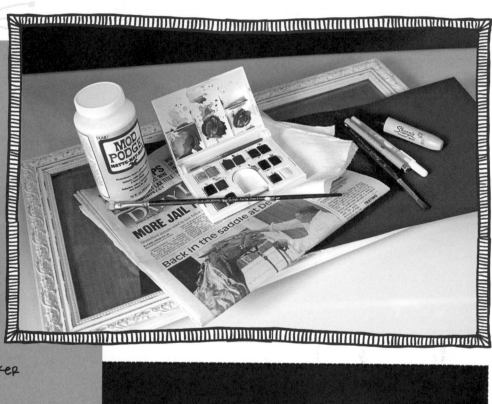

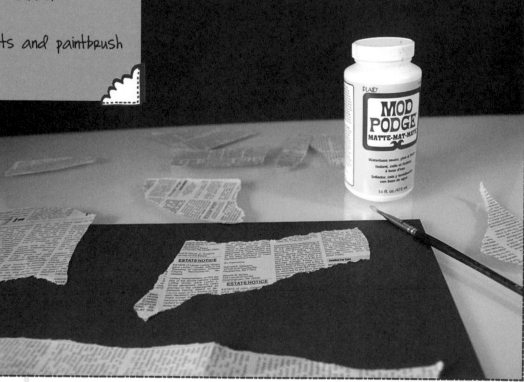

Step 1 Tear up the newspaper to get some irregular edges.

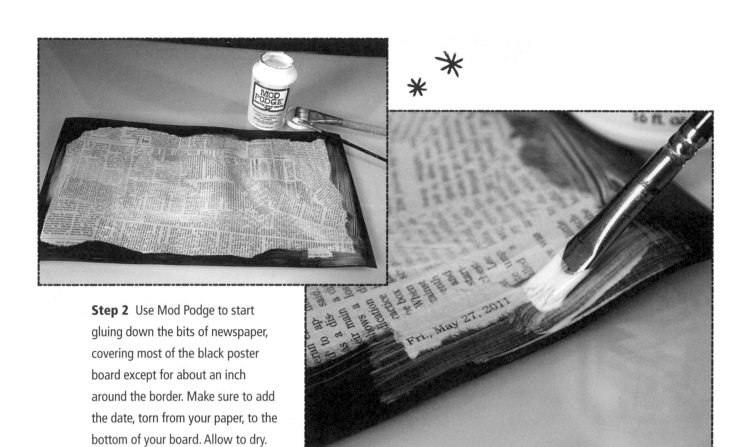

Step 2 Use Mod Podge to start gluing down the bits of newspaper, covering most of the black poster board except for about an inch around the border. Make sure to add the date, torn from your paper, to the bottom of your board. Allow to dry.

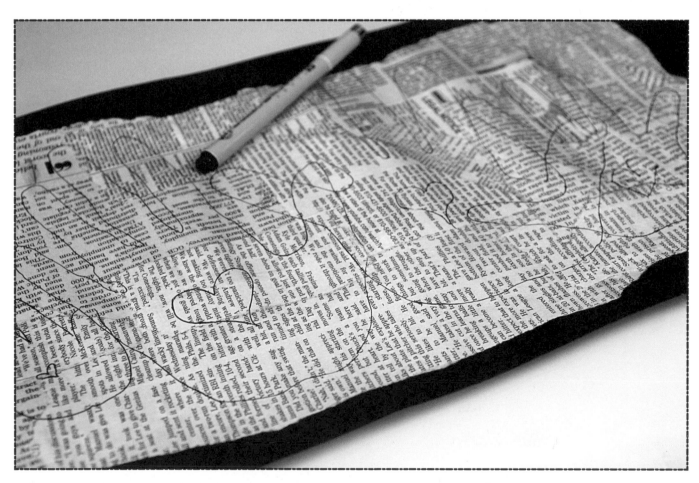

Step 3 Trace each family member's hand onto the newsprint. Overlap the hands slightly; then have each person draw a heart in the center of his/her handprint.

Step 4 Have each person fill his/her heart with doodles or a simple texture. Then trace over the outlines of each hand a few times. Don't worry about being too careful—wavy lines add character and a handmade feel.

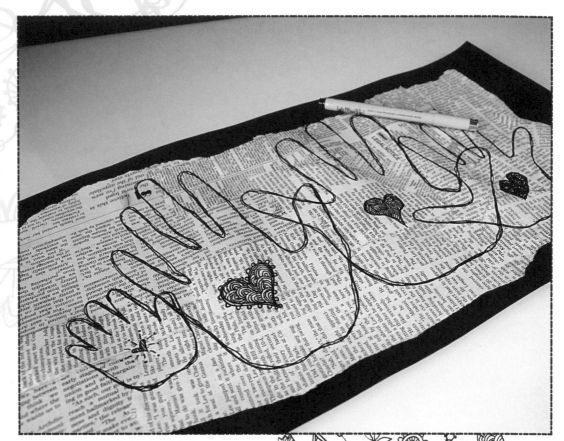

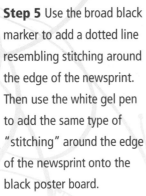

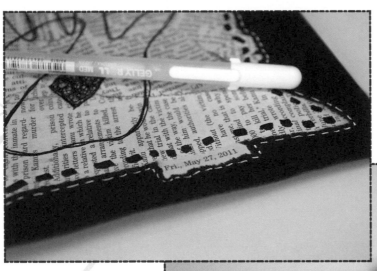

Step 5 Use the broad black marker to add a dotted line resembling stitching around the edge of the newsprint. Then use the white gel pen to add the same type of "stitching" around the edge of the newsprint onto the black poster board.

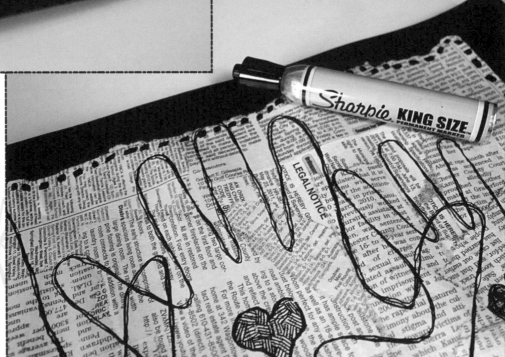

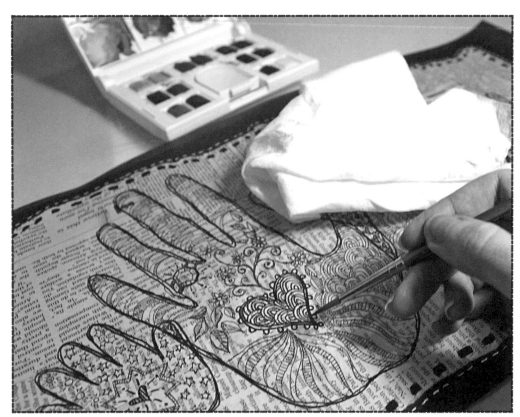

Step 6 Fill in each hand with random doodles, or have each person doodle inside his/her hand. Then doodle hearts in all of the areas where the hands overlap. Add muted washes of watercolor to the hands. Simply load your brush with water and lightly tap the watercolors to get the teeniest bit of pigment onto your brush. Dab any excess color from the art with a paper towel as you work.

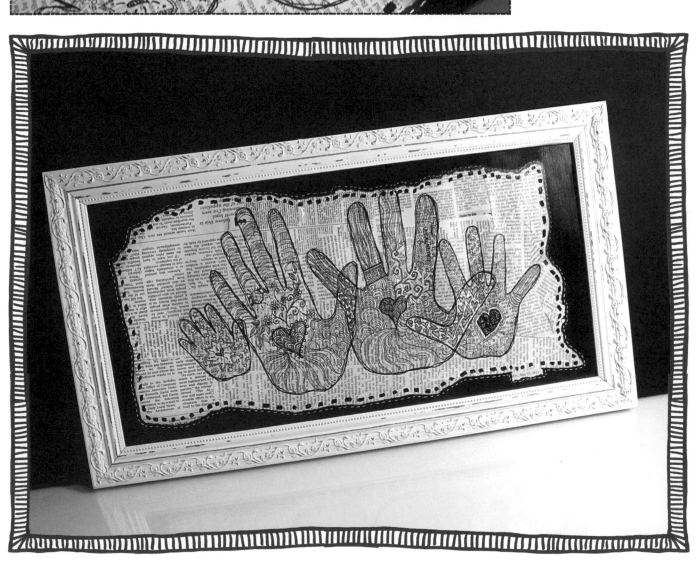

Step 7 Frame your artwork. Don't forget to tuck your family snapshots into the back of the frame. Before you know it, those little hands will be as big as yours. This project will preserve that memory and become a treasured family heirloom.

Creativity Prompt

Continuous-Line Scribbles

Draw some doodles the scribbly way! Keep your pen constantly moving and do not lift it from the page. Your goal is to achieve recognizable forms that are composed completely of scribbles. Use the opposite page to practice your doodles.

CLEVER IDEA

Create continuous-line scribbles on nice paper. When you have about 100, cut them to similar-sized squares and arrange them in a grid pattern on a poster board or newsprint. The collection makes fun, quirky wall art!

Filling the Page

Grow-a-Doodle

One of my favorite ways to start a project is to grow a doodle. Simply pick a place on the page and sketch a shape, building on it outward and upward until you've filled the page. Copy the example here or create your own on the opposite page. I've shown each stage of my drawing in a different color for demonstration, but feel free to use any colors you like.

Step 1 Draw a basic shape on the lower part of the page.

Step 2 Using the first shape as a base, doodle the next section. Think of the base as the "earth" with your artwork "growing" outward from it.

Step 3 Add different-sized elements so your drawing looks dynamic. For example, you might place some smaller designs next to larger elements.

Step 4 Continue adding onto each layer of your drawing until you are happy with the composition; then go back and add any detail or pops of color you like.

Practice
Here!

Jump Around!

One way to fill a large area and maintain balance is to jump around. That is, to continually move around the page until you've filled it in with your complete drawing. It helps to start with a few large doodles and work your way down to the smaller elements.

◀ **Step 1** Select a theme for your doodle. I chose an ornate paisley motif embellished with medallions.

▶ **Step 2** Beef up your original design elements by adding decorative borders; then doodle a medium-size motif (I picked a circle medallion) to begin filling in the white space.

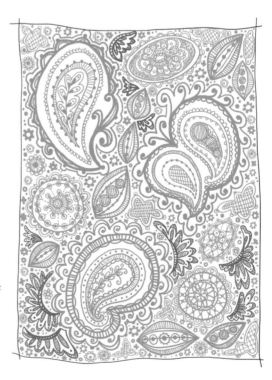

▶ **Step 3** Now doodle a smaller motif (I picked blue pods) and fill in the last bit of white space with tiny doodles. I used fuchsia wings to bend and fit the curving white space.

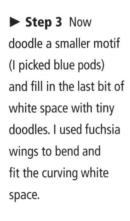

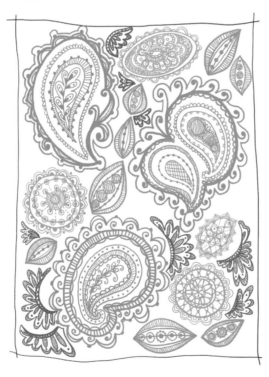

▶ **Step 4** Finally, add dots, stars, and other coordinating filler art to the rest of the page.

100

Practice Here!

TIP

When jumping around, work in like groupings for consistency. For example, I drew all the paisleys first, then I added the circle medallions, and so forth.

Doodled Masterpiece

Here's a project to prove that anyone can make artwork nifty enough to hang on the wall. If you know how to use a marker and a paintbrush, and you can rip up some tissue paper, you're in business! It's all about choosing the right materials and having a bit of patience.

Tools and Materials
- Wood board cut to preferred size
- Sandpaper
- Multicolored tissue paper
- Matte medium
- White acrylic paint
- 1-1/2" flat paintbrush
- Paper towels
- Various sizes of permanent black markers
- Multicolored permanent markers

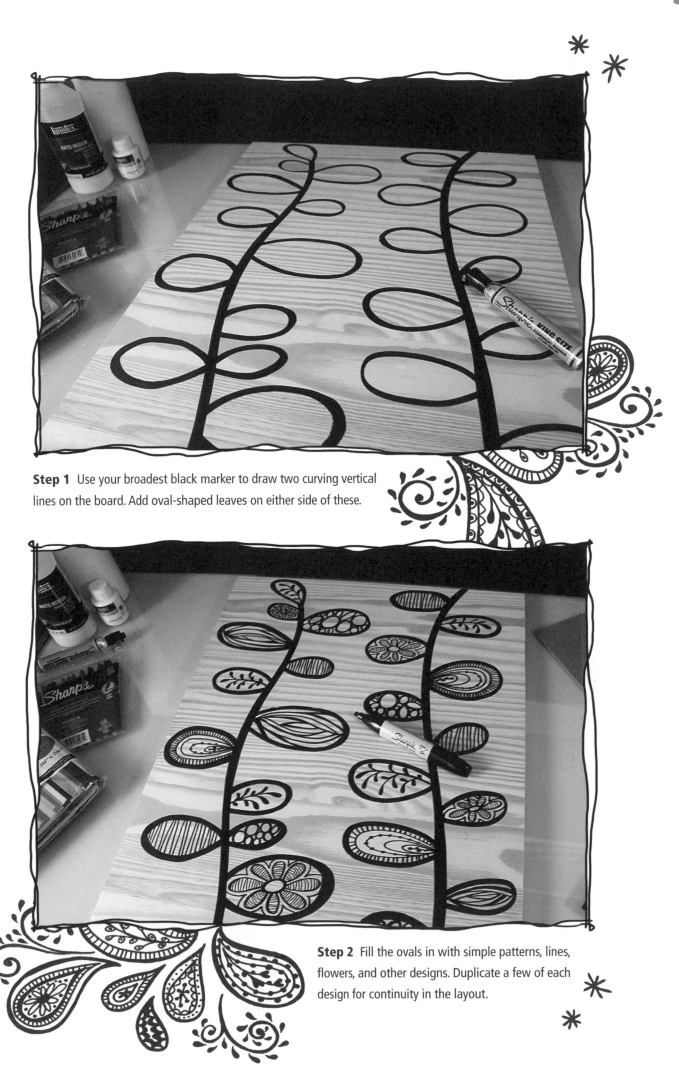

Step 1 Use your broadest black marker to draw two curving vertical lines on the board. Add oval-shaped leaves on either side of these.

Step 2 Fill the ovals in with simple patterns, lines, flowers, and other designs. Duplicate a few of each design for continuity in the layout.

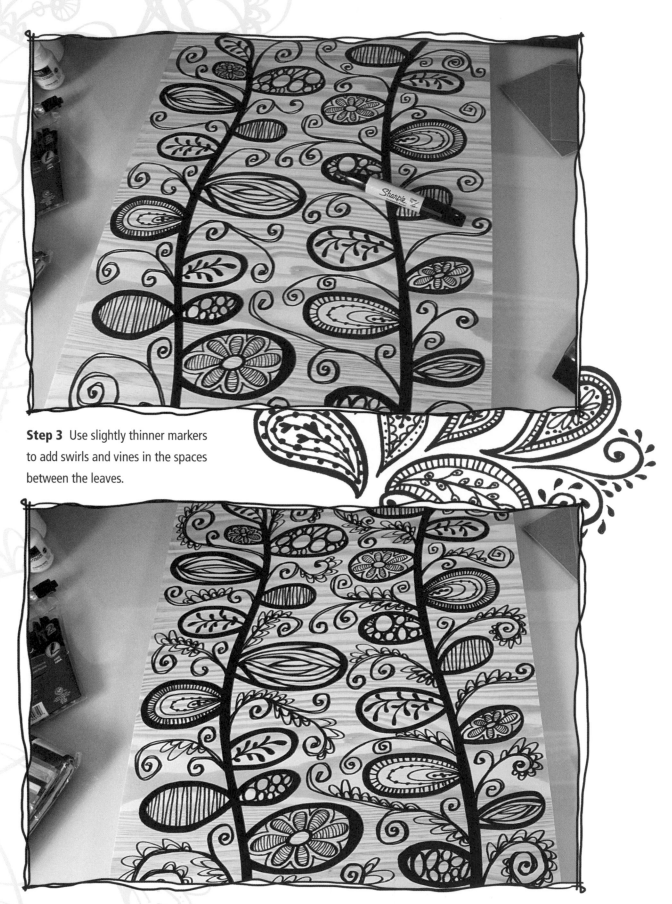

Step 3 Use slightly thinner markers to add swirls and vines in the spaces between the leaves.

Step 4 Add some scallops to your vines to create a little complexity and interest.

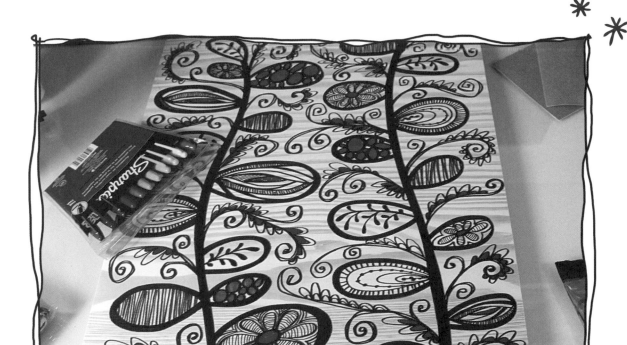

Step 5 Choose a few colored markers within the same color family, such as red, fuchsia, pink, and red-orange, or green, aqua, blue, and turquoise. Color in select elements in the design—not everything, just a few pops of color.

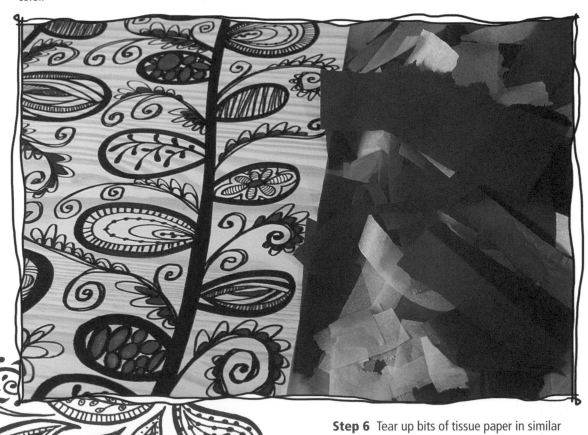

Step 6 Tear up bits of tissue paper in similar colors to the marker colors you selected, but add one or two complementary colors for fun.

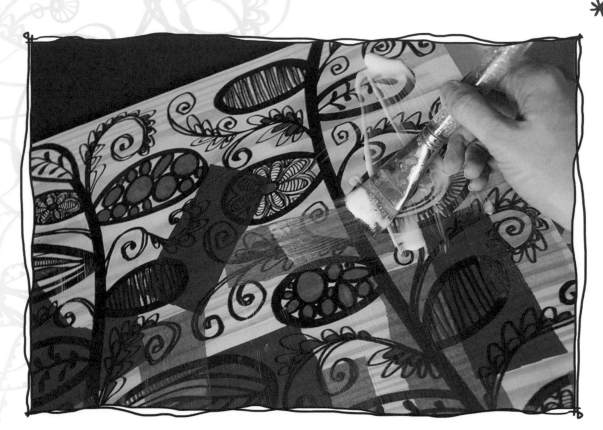

Step 7 Apply a thin layer of matte medium across the board with your flat brush. Lay down a tissue strip and paint over it with more matte medium. Don't overwork the tissue or it will tear. Keep a slightly damp paper towel handy to wipe excess medium from your brush as necessary.

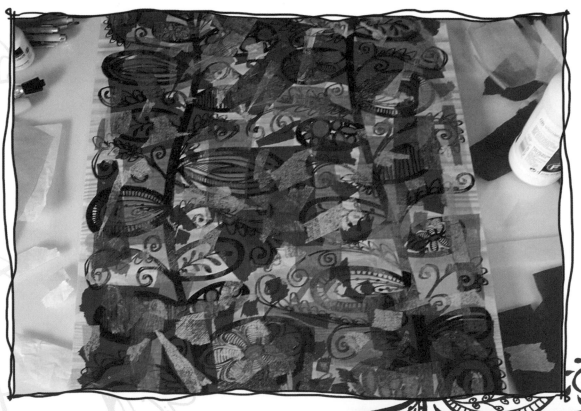

Step 8 Repeat step 7, alternating tissue colors and sizes. When the board is covered to your satisfaction, allow it to dry completely.

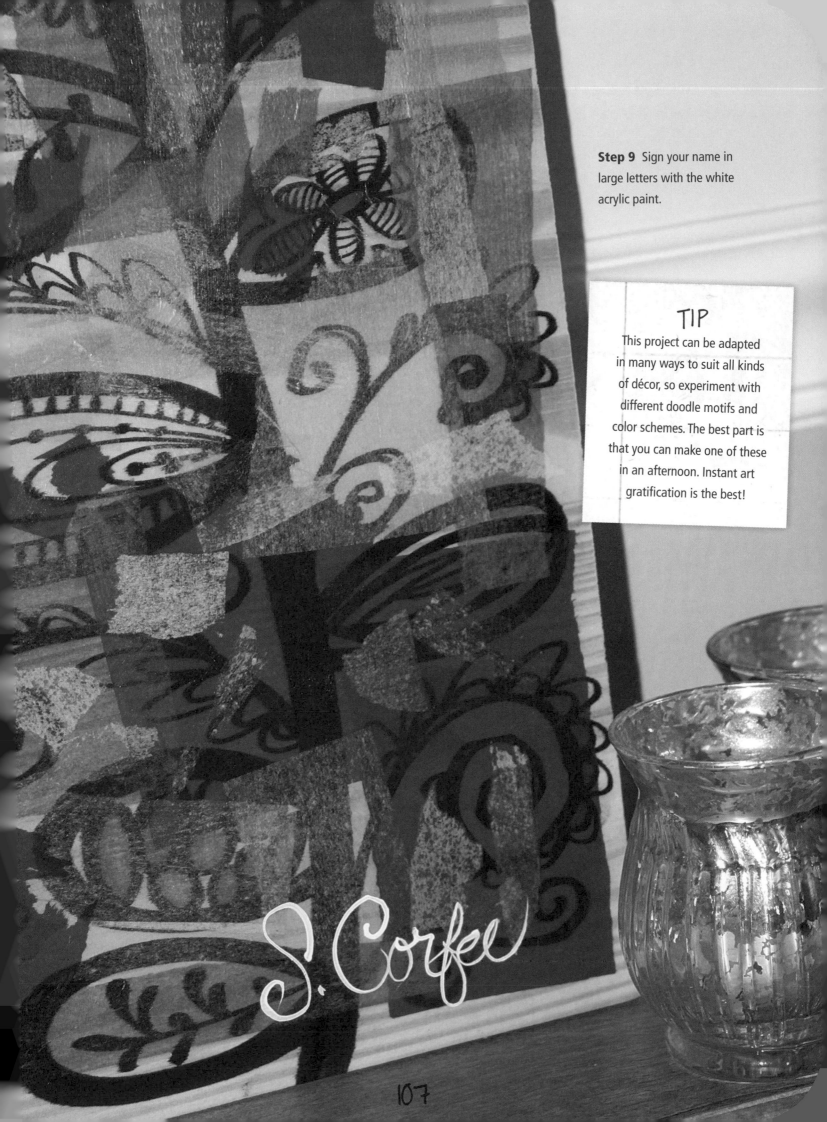

Step 9 Sign your name in large letters with the white acrylic paint.

TIP
This project can be adapted in many ways to suit all kinds of décor, so experiment with different doodle motifs and color schemes. The best part is that you can make one of these in an afternoon. Instant art gratification is the best!

Page O' Faces

Nothing is quite as inspiring as the endless combinations of eyes, noses, ears, mouths, and hair that make up the unique faces all around us. Think about the variety of faces you can draw from grandfatherly and grandmotherly types to tweens, teens, and children. Keep your drawings simple. Resist the urge to add too much detail or to be anatomically correct. Include at least one extreme feature on each character: a huge smile, teeny mouth, square face, blue hair, and more! Use the opposite page to practice your doodled faces.

TIP
Practice drawing faces that might correspond to certain jobs, such as a movie star, a ballet dancer, and a truck driver.

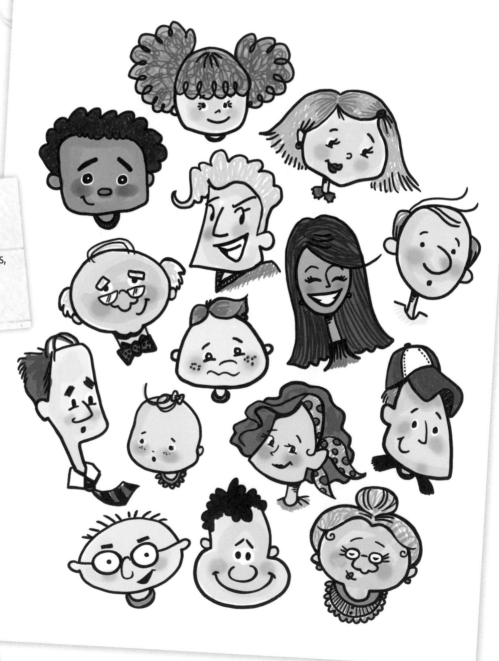

Practice Here!

Stream of Consciousness

Stream of consciousness doodles are meant to help you loosen up, stretch your imagination, and draw with a free spirit and no expectations. It provides an opportunity to put your pen to paper and simply allow your mind to wander. Using the doodles below as inspiration, practice drawing tangible objects on the opposite page; however, do not plan your doodles. The idea is for them to come to mind naturally. For example, if you draw a shoe, your mind may compel you to draw a dress, and then a necklace. Maybe the necklace reminds you of a kite string, which will make you think of a ball of twine. Get the idea? Don't dismiss any random idea that pops to mind. This is a great way to fill a page, as well as create a fun piece of wall art. The resulting jumble of "things" is almost guaranteed to be a snapshot of your personality. And that's pretty cool, too.

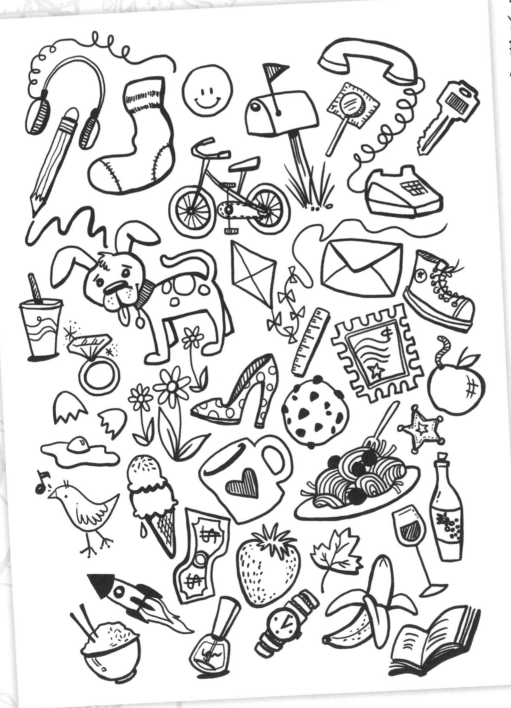

110

Practice Here!

Family Seek & Find Game

This family doodle activity is fun to create and makes an entertaining game for visitors to play.

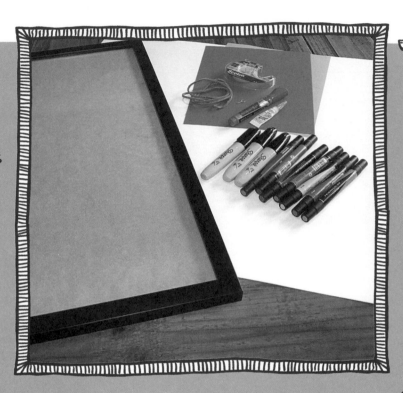

Tools and Materials

- Oversized poster paper
- Permanent markers
- Large wall frame with glass
- Dry erase marker
- Small eye screw
- Cord or ribbon
- Coordinating cardstock
- Pencil
- Kneaded eraser
- Double-sided adhesive tape
- Ruler

Step 1 Trim your poster paper to fit your frame.

Step 2 Use faint pencil lines to mark off the drawing area about 1" in around the sides of the poster. Then mark off an area in one corner, where you will list the hidden items. Mine measures 3-1/2" x 7-1/2".

Step 3 Have each family member doodle his/her favorite items in the drawing area using a black marker or pen with the same point size. For small- to medium-sized posters, you will want a finer point to draw smaller doodles. This will keep an even rhythm across the drawing so the doodles blend together more uniformly. Scatter the doodles around the space so there is an even mix of every artist's drawings across the page. If you use a large poster, you might want a thicker marker so the scale of your doodles better matches the size.

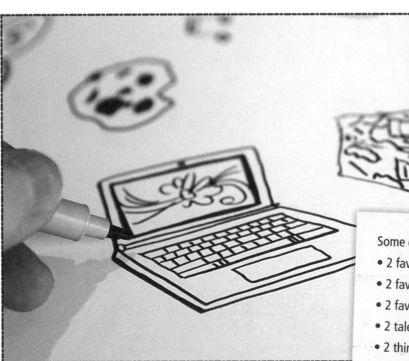

Step 4 Fill in the bulk of the remaining drawing area with random object doodles. These will throw folks off the trail when they are searching for your personalized hidden doodles!

Some doodle ideas for each artist include:
- 2 favorite articles of clothing
- 2 favorite foods
- 2 favorite hobbies
- 2 talents
- 2 things that other people associate with the artist (a favorite accessory, a word, a pet, etc.)
- Initials (doodle style, of course!)

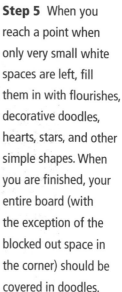

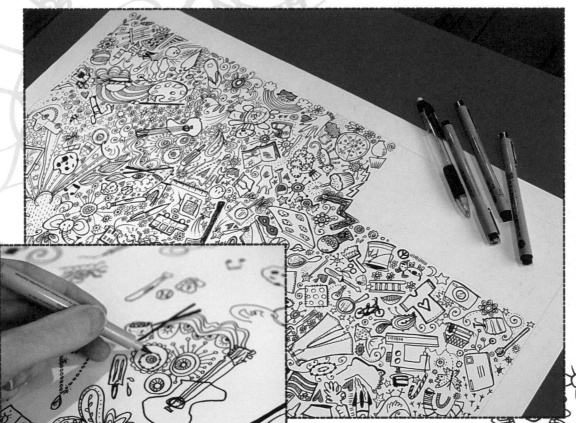

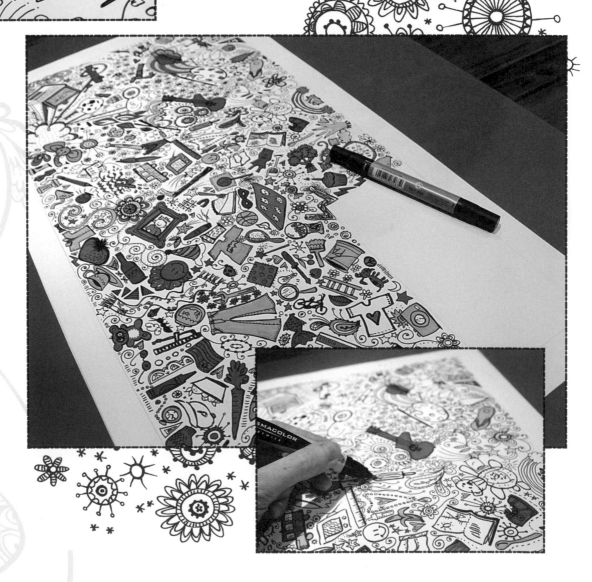

Step 5 When you reach a point when only very small white spaces are left, fill them in with flourishes, decorative doodles, hearts, stars, and other simple shapes. When you are finished, your entire board (with the exception of the blocked out space in the corner) should be covered in doodles.

Step 6 Choose five to seven colors from the same side of the color wheel so your finished piece has a monochromatic vibe. If possible, match the poster colors to the room where the art will hang. Add one color at a time to a selection of doodles, but don't color everything; leave a balance of black-and-white and colored doodles for a more interesting composition.

◀ **Step 7** Use a kneaded eraser to remove old sketch lines. Then type up a list of the hidden objects divided by artist on a piece of colored paper that matches the artwork. Attach it in the designated area.

▶ **Step 8** Mount the artwork in the frame; then add an eyehook to the side of the frame. Attach a dry-erase marker to a cord or ribbon and loop through the eyehook.

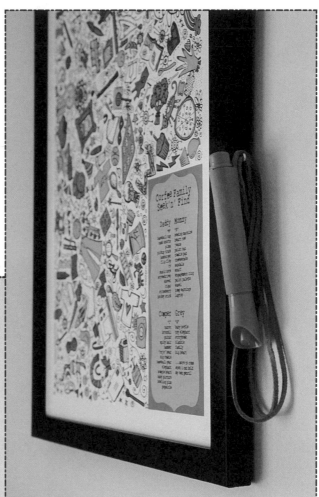

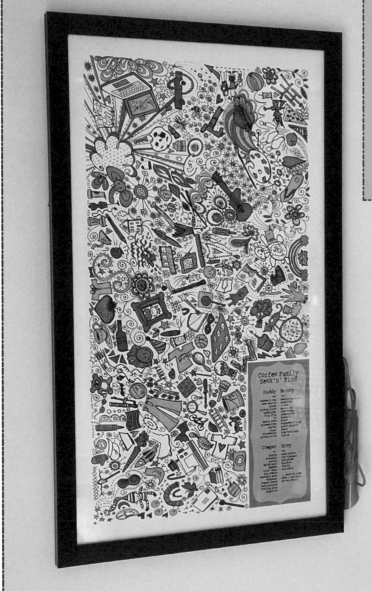

◀ **Step 9** Hang the artwork where guests and kids can play—searching for and circling the doodles with the dry erase marker, which wipes clean easily. This project is good fun and makes a great gift with endless possibilities!

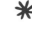

Whimsical Stuffed Toys

Channel your inner child and your wildest imagination! On the opposite page, doodle a variety of stuffed animals, dolls, monsters, and other creatures. This is a wonderful prompt to come back to time and again because it demands all of your creativity. Sure, you can draw dolls and teddy bears, but feel free to draw some kooky little characters, too! Doodle some poufy little guys with springy antennae. Give regular animals a quirky twist. (Could you imagine an elephant with wings?) Play with scale, and draw spindly, skinny legs on boxy shaped buddies. Then have even more fun by adding lots of color, texture, and accessories, such as stripy leg warmers, superhero masks, whatever you want. The sky's the limit!

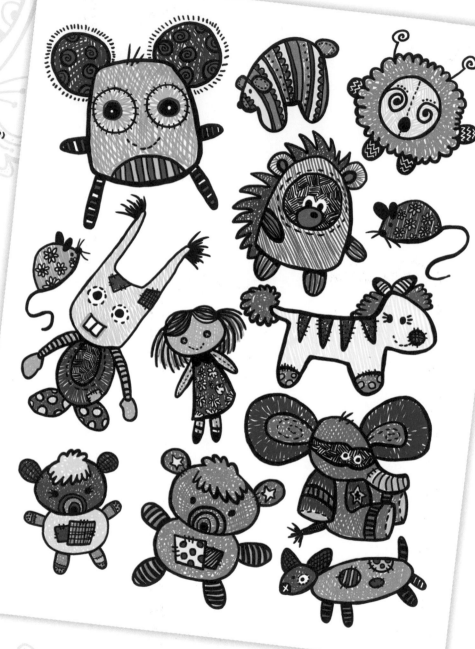

Practice Here!

Animated Doodling

Giving "life" to your doodles by implying light, sparkle, and motion is not as difficult as you might think. In fact, it's quite easy to show these things in a rudimentary yet clever way. Think of things that glow, move, flutter, and twinkle. Then use some simple design elements to communicate these ideas. On the opposite page, add a trail of pixie dust to the fairy's wand using the steps below to guide you. Better yet, doodle your own pixie dust trail!

Step 1 Doodle a dashed spiral down the page to show the glittery swooshes of the fairy's wand.

Step 2 Then add tiny, crisscross starbursts surrounded by halos of "light."

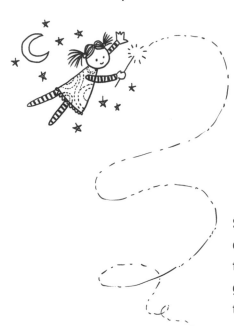

Step 3 For added sparkle, draw lots of little dots around the trail.

Step 4 Finally, add dotted-line swirls and spirals extending from the main sparkle trail for a whimsical touch.

Embroidered Wishing Star Stuffie

Turn your doodles into adorable embroidery on stuffed wishing star, which makes the perfect buddy whose back pocket holds wishes, doodled notes, or a first tooth for the tooth fairy. This is the kind of handmade treasure that will be passed from one generation to the next.

Tools and Materials

- Osnaburg or other cotton fabric
- Fiberfill stuffing
- Embroidery hoop
- Scissors
- Colored pencils
- Embroidery thread in an assortment of colors
- Embroidery needles
- Pins
- Sewing needle and thread to match fabric
- Iron (optional)
- Sewing machine (optional)

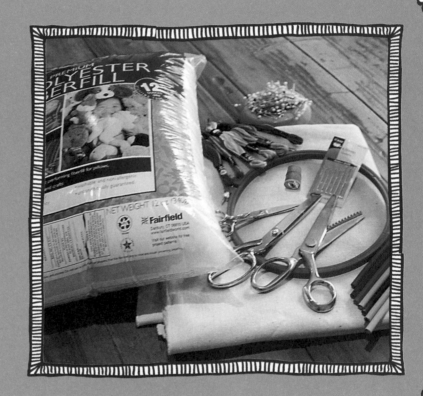

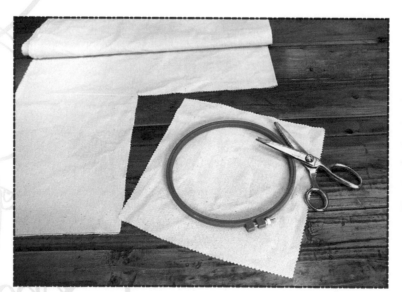

Step 1 Choose a hoop size that will fit your entire embroidered design. Then cut three squares of fabric that are each about 3″ to 4″ larger than your embroidery hoop.

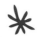

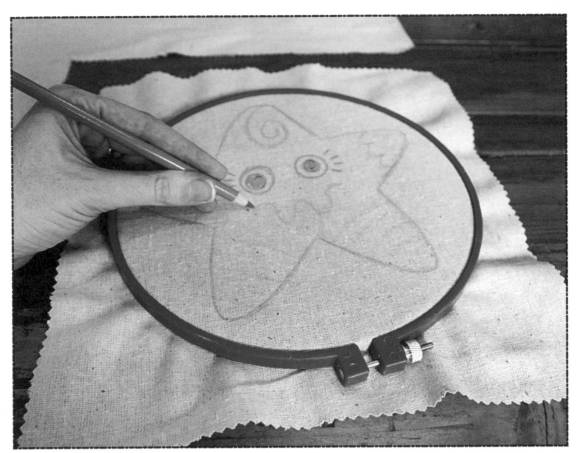

Step 2 Stretch one piece of fabric on your hoop and use colored pencils to doodle your star-shaped design. A simple doodle is fine, but feel free to be more elaborate if you are experienced with embroidery.

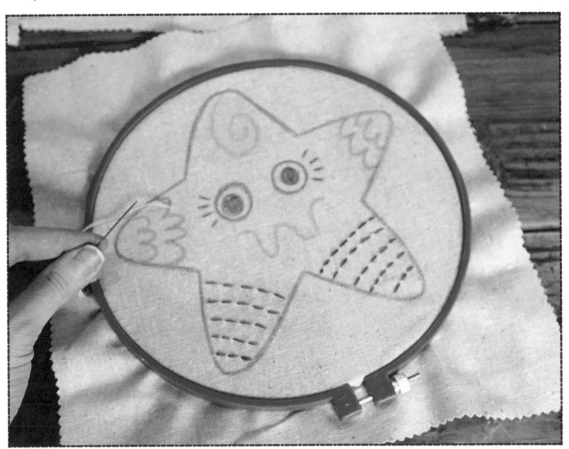

Step 3 Next, embroider your doodles in different colors, tying off knots on the back of the fabric as you go.

Step 4 Remove the embroidery from the hoop. Measure 1″ out from your star design and draw a border outline around it, following the contours of the shape.

 Step 5 Cut out the shape along the pencil-drawn border.

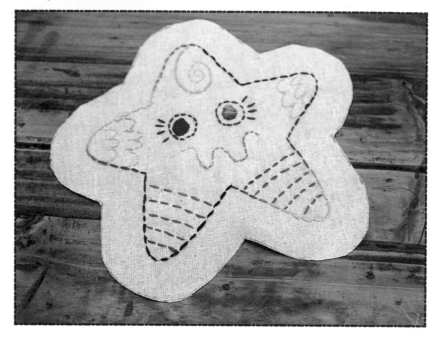

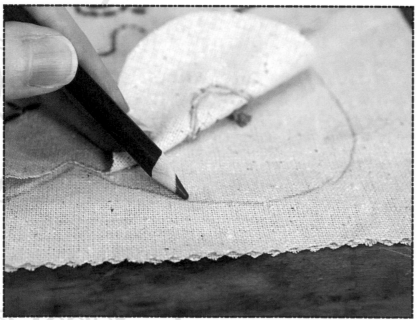

Step 6 Place the cut-out star shape on one of the remaining fabric squares; then use a pencil to lightly trace around the shape. When you are finished, cut around the outline so that you have another star shape. Repeat this step on the third fabric square.

Step 7 Cut the top peak off of one of the plain fabric stars; then fold over twice to form a hem. Use an iron to press the hem in place.

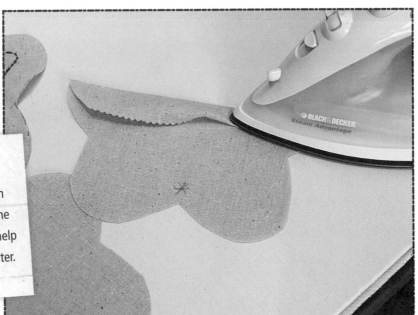

TIP
Draw a faint asterisk in the same location on the bottom of each star to help you align the shapes later.

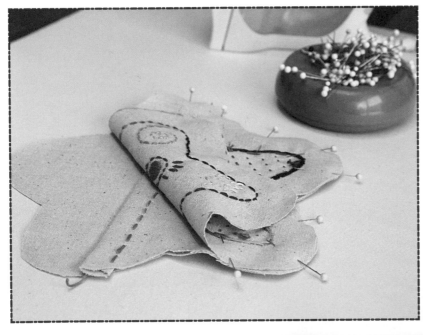

Step 8 Embroider a decorative stitch across the pressed hem of the shape from step 7. Align and stack the stars as follows: Plain fabric star, right side up; hemmed star, right side up; embroidered star, right side down (as shown at left). Pin the shapes in place.

Step 9 Next, stitch a 3/8" seam all the way around the shape, leaving an opening along one edge for turning and stuffing.

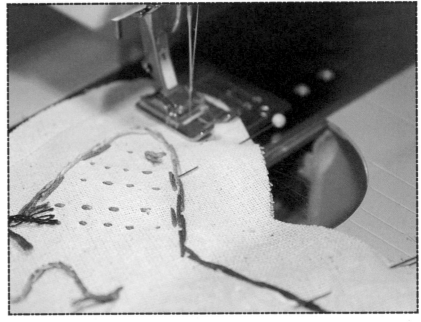

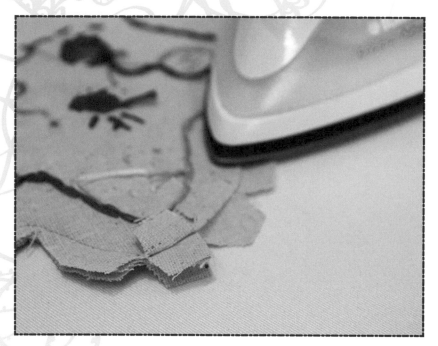

Step 10 Use scissors to trim seam allowance and notch edges so that the star lies flat once it's turned. Use an iron to press back the edges along the opening. This makes creases that will aid in creating a clean closure after stuffing so that it will be much easier to slipstitch.

Step 11 Turn the star inside out and press the seams flat.

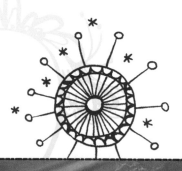

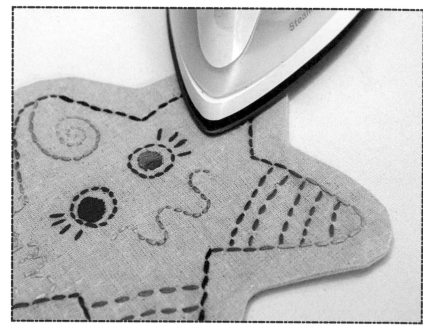

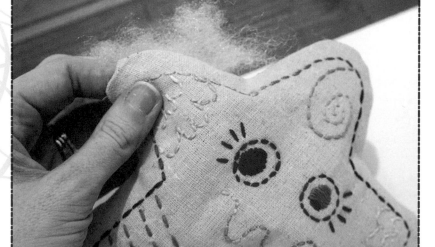

Step 12 Stuff the star with the fiberfill, packing each point firmly.

Step 13 Slipstitch the opening closed.

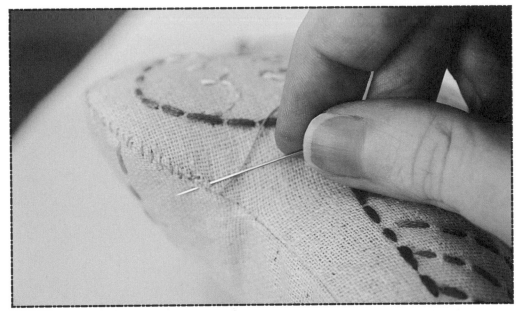

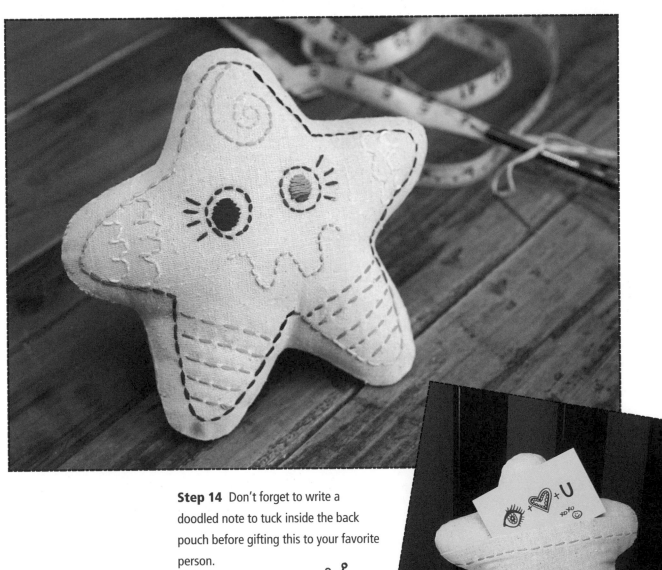

Step 14 Don't forget to write a doodled note to tuck inside the back pouch before gifting this to your favorite person.

125

* Raid Your Closet!

Doodling objects can be lots of fun, and doodling wearable items is the best! For this prompt, you will draw inspiration from your closet, from magazines, from the mall, and anywhere else you might find elements of fashion.

Here are some tips to get your started:

• Don't get caught up in overly detailed patterns, stitching lines, and proportions. Instead, think of a garment and imagine a simplified version.

• Use bold color, and focus on strong shapes and basic styling.

• Draw your dream wardrobe, as well as items you love to wear everyday.

• Doodle costumes, uniforms, and pajamas.

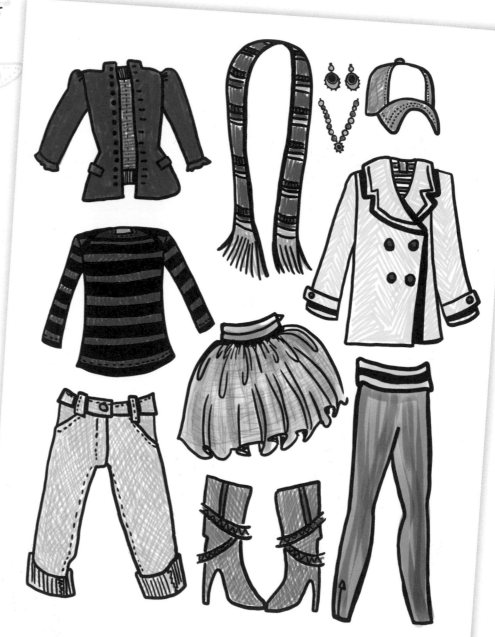

TIP
With a little planning and the addition of a doodled "person," you could adapt this prompt to create a one-of-a-kind paper-doll collection for your favorite kiddo.

Practice Here!

Adding Outlines

Outlining your doodles is a great way to make an impact on your final drawings, as well as to fill up white space. Watch how a simple flower can be easily embellished to create an ornate design. Then practice enhancing the flower yourself in the space provided on the opposite page.

Step 1 Draw a circle surrounded by petals to create a flower—your central shape.

Step 2 Outline the simple shape and add a black dot to the end of each petal; then outline again. Notice how you've changed the central shape by adding the bulb-like extension to each petal.

Step 3 Next, add a simple series of arcs encircling your outlines; then add another outline with curved pointy tips around each arc from the previous row.

Step 4 Draw another row of wider connecting arcs.

Step 5 Fill the space between the last two outlined rows with stripes for interest.

Step 6 Finally, draw a ring of scallops all the way around the design.

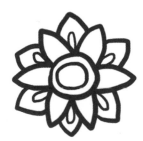

Mixed-Up Doodled Hobo Bag

This hobo bag has three types of doodly goodness: 1) embossed leather, 2) doodled fabric patches, and 3) doodled iron-on transfers. Master these techniques, and you'll be embellishing bags for all of your friends in no time!

Tools and Materials

- Cotton hobo bag (blank)
- Inkjet transfer paper
- Fabric markers
- Black permanent markers
- Colorful cotton fabric with doodle-theme print
- Fusible webbing
- Pinking shears
- Men's leather belt
- All-purpose wood/leather embossing tool
- Leather punch
- Embroidery floss and needle
- Colorful fabric scraps
- Iron
- Magnetic purse snap (optional)

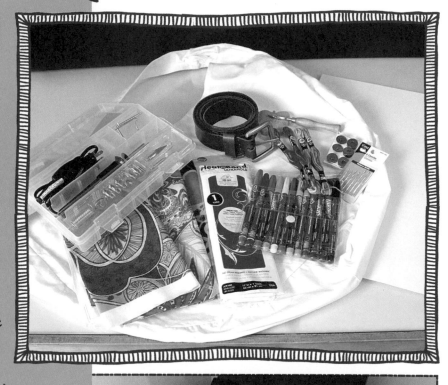

Step 1 Use a black ink pen to fill a page with whimsical doodles. Scan your art into your computer; then print the design onto inkjet transfer paper. I used a soft finish transfer paper to avoid the plastic feel you get with average transfer sheets. (Note: Consult your printer manual to ensure it is capable of printing on transfer paper.)

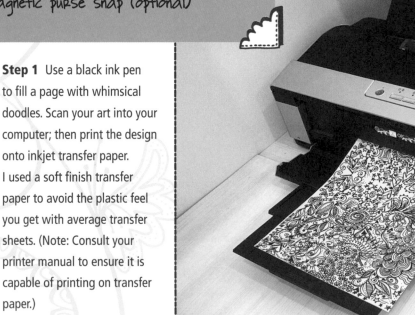

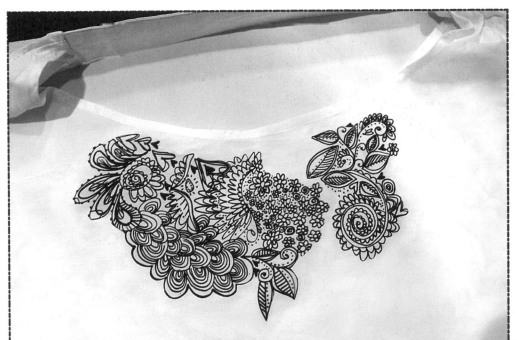

Step 2 Cut out your doodle design into various shapes and arrange them at the top opening edge of the bag.

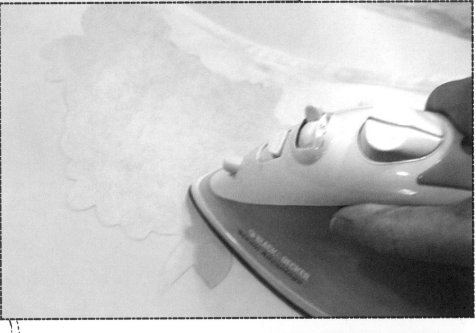

Step 3 Follow the transfer paper instructions to apply the transfers with a hot iron. Remove the transfer film to reveal your design.

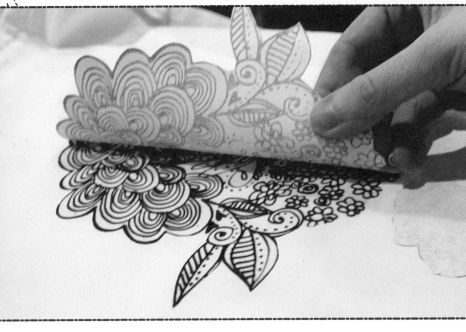

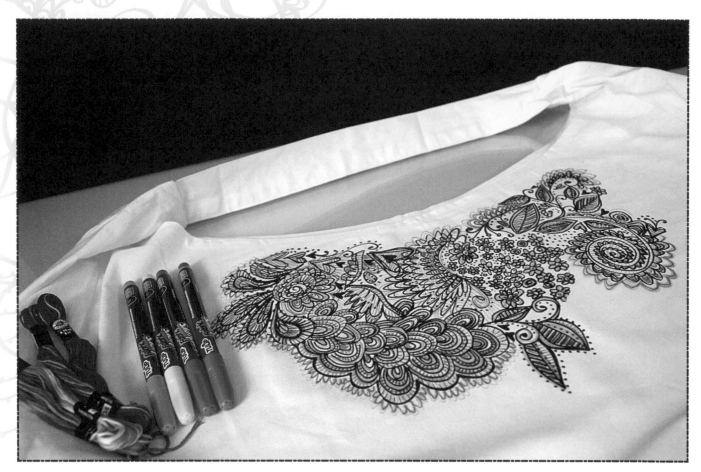

Step 4 When the transfer has cooled, use fabric markers to add color.

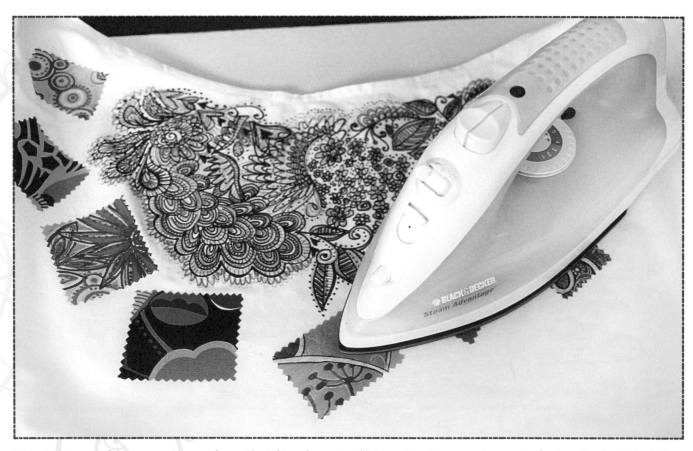

Step 5 Trim your fabric scraps into patches with pinking shears to add interest and to prevent excessive fraying. Use fusible webbing to add the patches in a semi-circle beneath the transfers. (Note: Two of the fabrics I used are my own doodled designs that I had printed through an online textile printing company. You can try your own!)

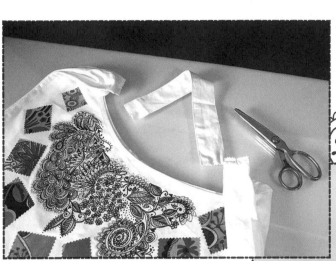

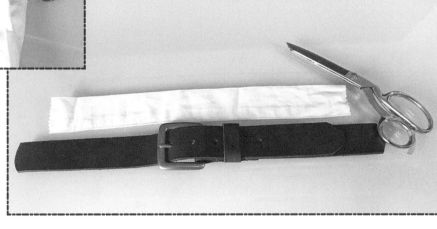

Step 6 Cut the cotton strap off the bag and use it as a rough guide to cut the length of the leather belt. Fasten the belt buckle and center it before cutting.

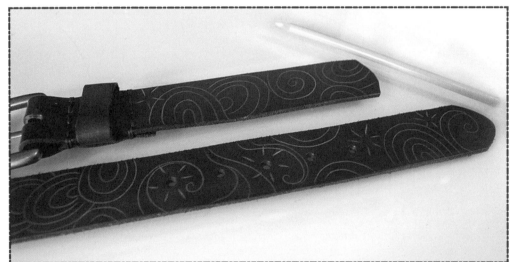

Step 7 Unbuckle the belt and use a white pencil to lightly doodle a design onto the pieces.

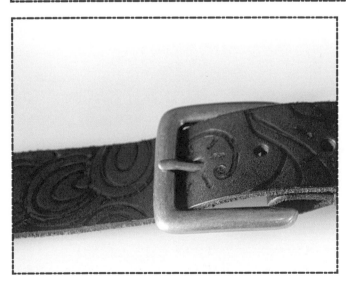

Step 8 Use the leather embossing tool to imprint the doodled designs into the belt.

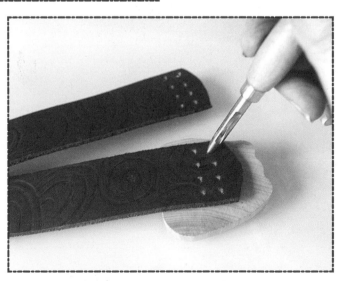

Step 9 Now use the leather punch to add two rows of holes at the ends of the belt straps. Four holes will create three stitches.

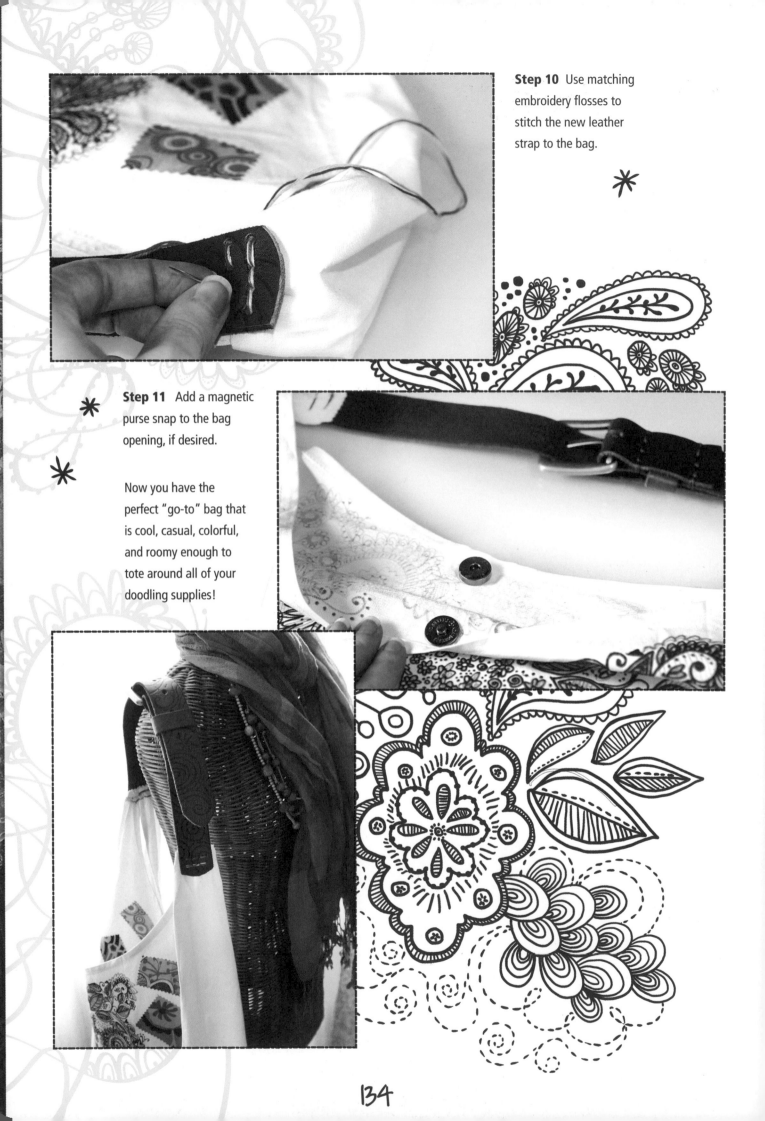

Step 10 Use matching embroidery flosses to stitch the new leather strap to the bag.

Step 11 Add a magnetic purse snap to the bag opening, if desired.

Now you have the perfect "go-to" bag that is cool, casual, colorful, and roomy enough to tote around all of your doodling supplies!

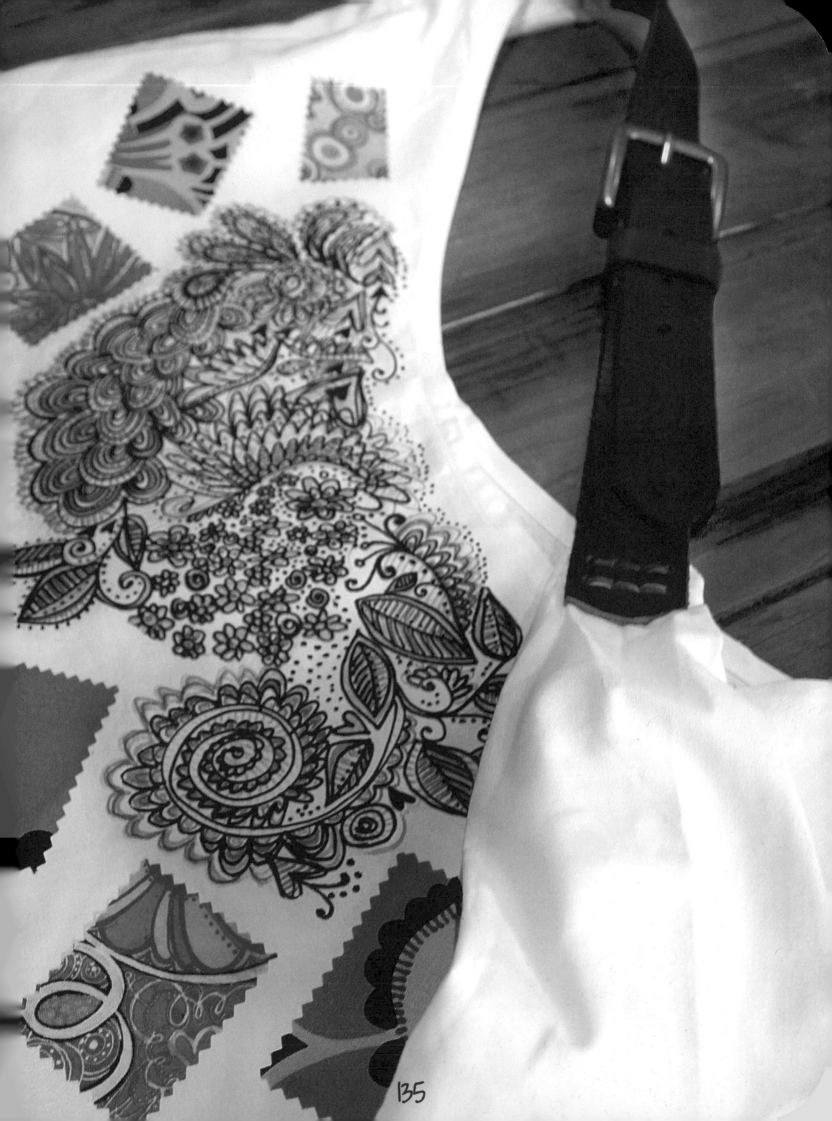

Idea
Gallery

Doodled Paintings

Doodling is a great way to update an abstract painting that you're tired of, as well as to add beautiful detail to a painting of your own creation. I love to make textural color-study paintings and then overlay them with intricate doodles. There is something that intrigues me about the combination of bold color and tiny subtle flourishes of swirling lines that are perceptible from across a room and draw you in for a closer look.

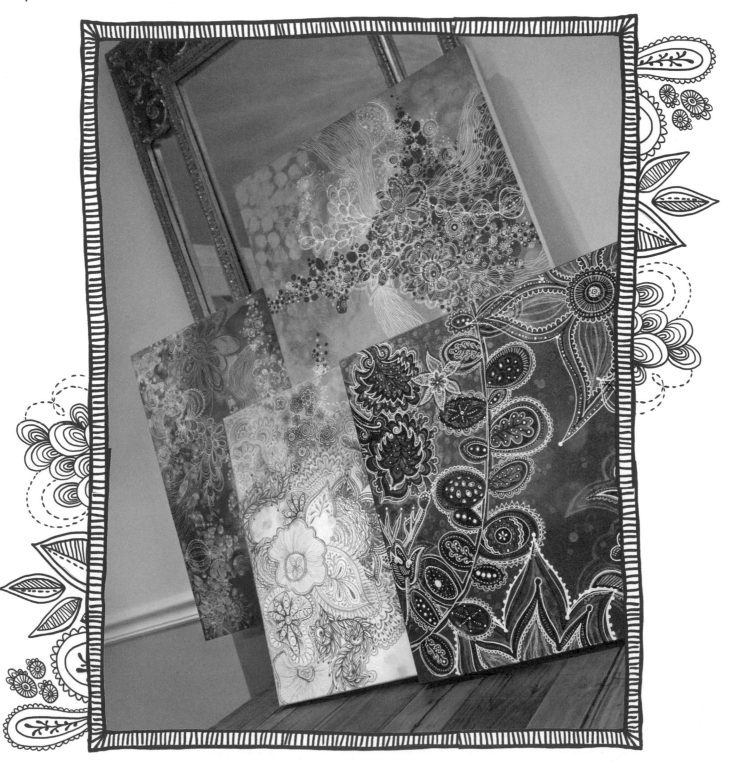

✳ Quote Somebody Brilliant!
We all have favorite
words that we like to
live by. Turning those
words into wall art is a
great way to show your
personality and have a
daily reminder of some
wise sentiments. Doodle
a favorite quote to hang
in your home. The casual
feel of a doodled quote
or phrase makes a
charming addition to
any home.

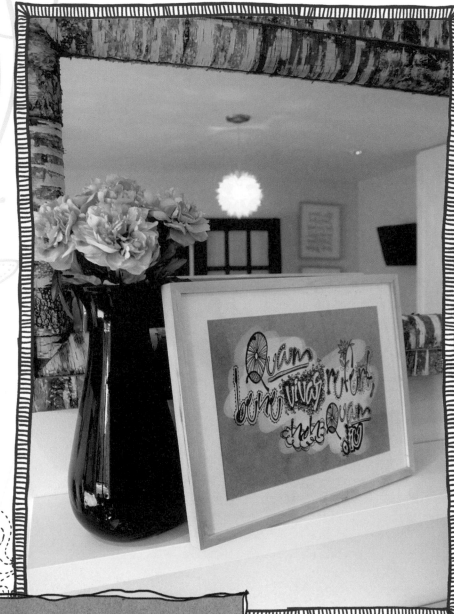

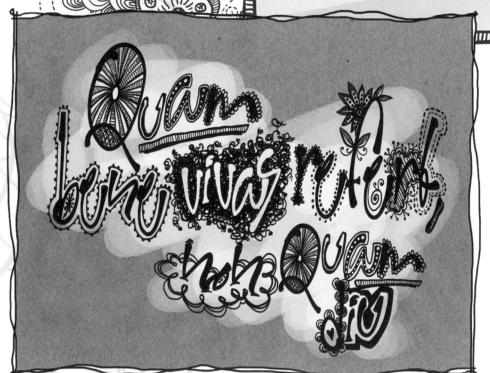

To add a bit of mystery, doodle your
quote in a foreign language, such
as I did with this Latin phrase that
means "It is how well you live that
matters, not how long."

Hidden Meaning Portraits

A picture is worth a thousand words. So instead of creating a standard portrait, try designing one that is full of hidden meaning and tells volumes about the subject. If you are adept at sketching portraits, try a more realistic representation. If you are just beginning, go with a cartoon-style caricature. In both cases, you can take tremendous artistic license with the hair, adding important dates; names of children, pets, and spouses; or tiny doodles of favorite things or hobbies, as well as any other objects that hold special meaning. Portraits like these reveal something new with each viewing.

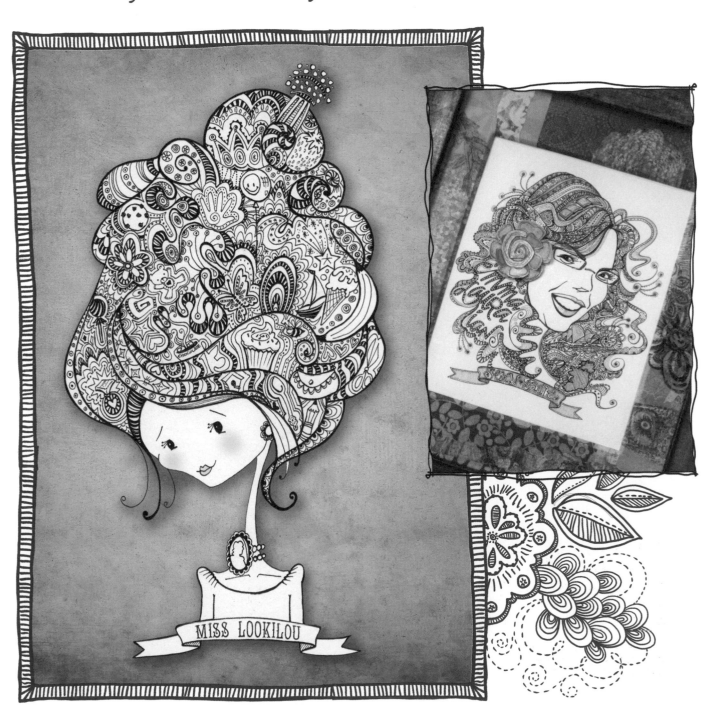

MISS LOOKILOU

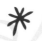

Make a Doodle-Fill

Any simple silhouette, such as a star, a heart, a geometric shape, or even a letter can be transformed into a doodle fill. Try filling a leaf shape with simple swirls and curlicues to make some autumn-themed place cards; fill a heart shape with smaller heart doodles, pet names, and loving sentiments for a keepsake Valentine; or fill in fabric letter shapes with words and objects, and sew them onto decorative pillows. Look closely at the doodle-filled letters on page 141. Then turn to pages 142-143 to try your hand at filling them in with doodles.

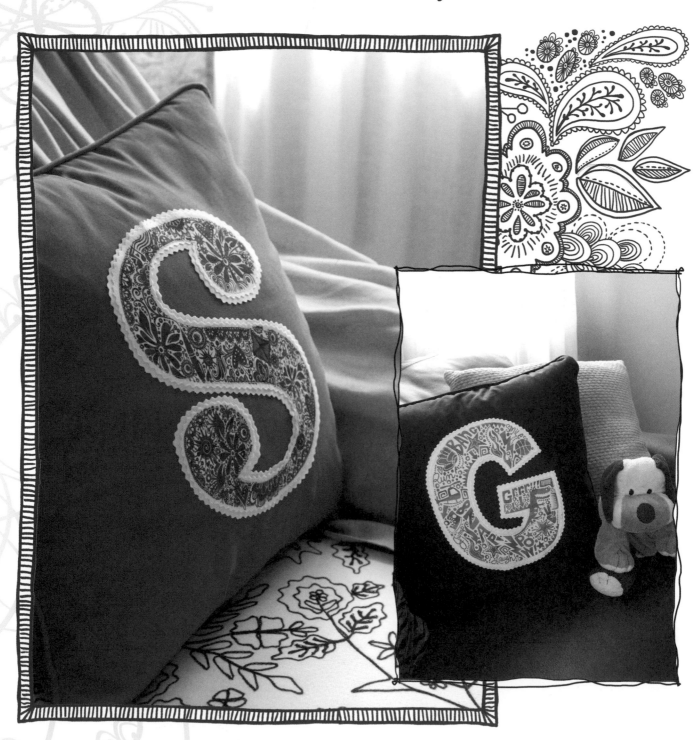

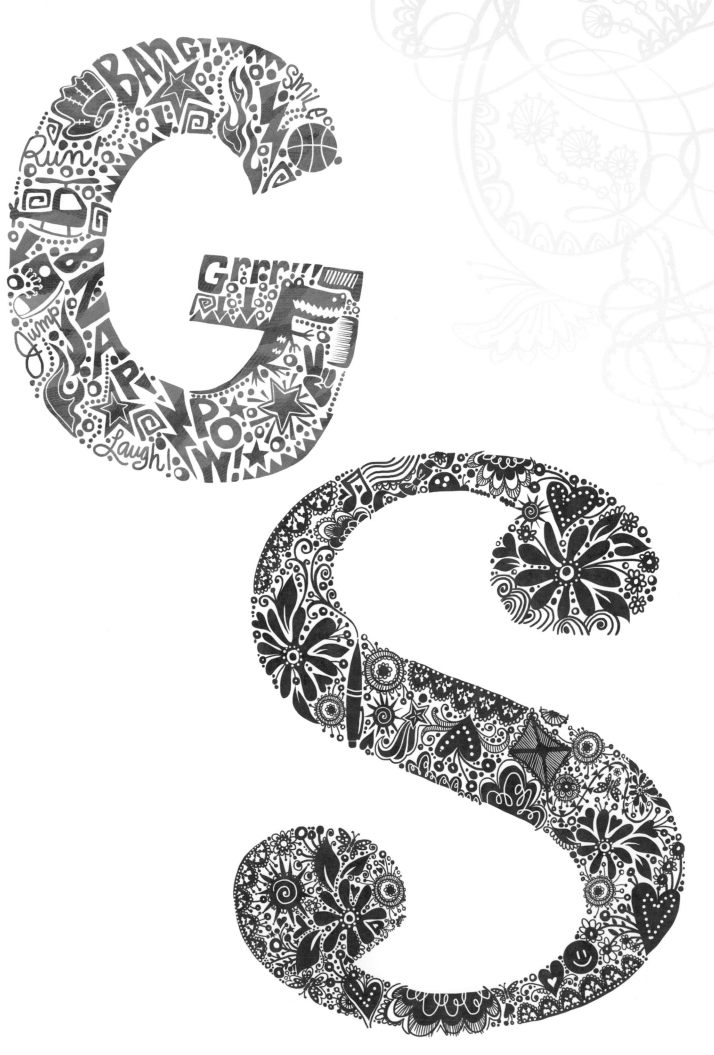

G

About the Author

Stephanie Corfee is a full-time freelance artist
and designer living in Malvern, Pennsylvania.
She has worked in advertising and marketing
and previously owned her own wedding gown
design studio. Today Stephanie enjoys the creative
freedom that comes from owning her own business
while doing what she loves. She has a colorful,
bohemian personal aesthetic and loves creating
fun, whimsical art for children.
Visit www.stephaniecorfee.com.